WILD PRAIRIE

WILD

JAMES R. PAGE

foreword by CANDACE SAVAGE

PRAIRIE

A PHOTOGRAPHER'S

PERSONAL

JOURNEY

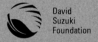

David
Suzuki
Foundation

GREYSTONE BOOKS

Douglas & McIntyre Publishing Group

Vancouver/Toronto/Berkeley

For Robert and Mette Ducan

Greystone Books
A division of Douglas & McIntyre Ltd.
2323 Quebec Street, Suite 201
Vancouver, British Columbia
Canada V5T 4S7
www.greystonebooks.com

David Suzuki Foundation
2211 West 4th Avenue, Suite 219
Vancouver, British Columbia
Canada V6K 4S2

Editing by Nancy Flight
Jacket and text design by Peter Cocking
Jacket photograph by James R. Page
Title page photo: Medicine Lake National
Wildlife Refuge, Montana
Map by Stuart Daniel/Starshell Maps
Printed and bound in China by C&C Offset
Printed on acid-free paper
Distributed in the U.S. by Publishers Group West

We gratefully acknowledge the financial support of the
Canada Council for the Arts, the British Columbia Arts
Council, and the Government of Canada through the
Book Publishing Industry Development Program (BPIDP)
for our publishing activities.

Library and Archives Canada Cataloguing in Publication
Page, James R. (James Robert), 1948–
Wild prairie : a photographer's personal journey /
James R. Page ; foreword by Candace Savage.

Co-published by the David Suzuki Foundation.
ISBN 1-55365-121-9

1. Landscape photography—Prairie Provinces.
2. Landscape photography—United States. 3. Prairies—
Canada—Pictorial works. 4. Prairies—United States—
Pictorial works. 5. Natural history—Prairie
Provinces—Pictorial works. 6. Natural history—
United States—Pictorial works. 7. Page, James R.
(James Robert), 1948– —Travel—Prairie Provinces.
8. Page, James R. (James Robert), 1948– —Travel—
United States. I. David Suzuki Foundation. II. Title.
QH541.5.P7P33 2005 779'.36712'092
C2005-900677-3

Library of Congress Cataloging-in-Publication Data
Page, James R. (James Robert), 1948–
Wild prairie : a photographer's personal journey /
James R. Page ; foreword by Candace Savage.

p. cm.
"David Suzuki Foundation."
ISBN 1-55365-121-9 (cloth : alk. paper)

1. Prairies—North America—Pictorial works.
I. David Suzuki Foundation. II. Title.
QH87.7.P34 2005
508.315'3'097—dc22 2005040444

CONTENTS

2479

VAL MARIE, SASKATCHEWAN, is a typical weather-beaten little prairie town, with peeling storefronts, boarded-up houses, and a main street with as many vacant spaces as a cowpoke's gap-toothed grin. The population has been in free fall for many years and is now hovering bravely at around a hundred. All in all, it's not the kind of place where you would expect to find artistic inspiration or to meet people with a joyful, forward-looking vision.

But as anyone who has lived on the prairies will tell you, there's more to this country than immediately meets the eye, and the village of Val Marie is a case in point. Behind its down-at-the-heels façade, a new culture and economy are gradually taking shape, with the conservation of wild prairie as the centerpiece. Not only is Val Marie the administrative and scientific hub of Canada's still-evolving Grasslands National Park, but it is also home to a community-based organization of grass huggers who have taken the name of Prairie Wind and Silver Sage. And it is thanks to the creative energy of this group that I first encountered the photography of James R. Page.

Prairie Wind and Silver Sage operates from a handsome one-room schoolhouse on the edge of Val Marie that has been converted into a visitors' center and museum. In the summer of 2001, someone came up with the idea of turning the former cloakroom, where generations of students had stored their coats and boots, into a minigallery of grassland art. A show of prairie images by half a dozen photographers opened there that June, with Val Marie's own Jim Page among them. When I happened by later that summer, I was surprised to find this

new cultural shoot pushing up out of the land and even more delighted by the quality of the photography on exhibit. But as high as the general standard was, Jim's work stood out from the rest, both for its technical proficiency and for its intelligence. Here was a mind that perceived landscape where others saw only space, an eye that was tuned to the special beauty of the prairie. I immediately engaged him as the principal photographer for my book *Prairie: A Natural History,* which was published by Greystone Books in 2004.

One of the many qualities that I appreciate in Jim's work is his sensitivity to scale. Grasslands challenge our senses, calling us to open our eyes to impossibly broad horizons and then, in the very next breath, to focus on some improbably tiny critter hidden in the grass. Jim has an eye for the big picture, as you will see, yet it does not blind him to the exquisite detail of the little things.

Although his images are invariably lovely, his vision is not all sweetness and light. There is a fierceness in his work that I admire, and a fearlessness. He has to be some kind of fool, perhaps a holy one, to be out there with his camera in the half-light of dawn, in the glare of lightning, in the bloodless glow of winter. The wild prairie matters in these images. If this book has an overall message, that is it: The wild prairie matters. Jim Page's photographs invite us to look toward a future in which native grasslands are valued as they deserve, and the prairie wind and silver sage are a centerpiece of all our love and concern.

CANDACE SAVAGE

PREFACE

ONE SWELTERING JUNE evening in 1989 in Grasslands National Park, Saskatchewan, I received a startling introduction to the raw and powerful dynamics of a prairie electrical storm. I was photographing wildlife, flowers, and landscapes—my first time venturing east from the Rockies across this vast and personally undiscovered prairie turf. My tent, pitched on a flat expanse of hard-baked ground, lay exposed to the elements. I tried to read a book by candlelight, aware of distant lightning flickering over low, rolling hills on the horizon. From dead calm, the wind rose to a roaring crescendo. Then the sky exploded around me, illuminating my surroundings in electric blue staccato flashes, while I huddled, unnerved in the face of such fury. Somehow I fell into a fitful sleep, with the tent ceiling whap-whapping

. . .

Midsummer lightning illuminates the sky over
Grasslands National Park, Saskatchewan.

[1]

down against my sleeping bag, poles bowing out at impossible angles, thunder booming, rain hammering, wind shrieking.

Eventually the storm rumbled away, dissipating. The next morning I was amazed to discover that gumbo clay had replaced the dry, cracked prairie earth. It was like walking on ball bearings, each boot clotted with heavy, slippery goop, every footstep a new adventure. I decided to leave. My car barely managed the muddy park roads, barely got me to safety up the big hill on the main Frenchman River Valley road.

At the time, I had no idea that this drama in the dark would eventually propel me on one of my life's great adventures. I returned to my home in British Columbia and carried on with my freelance careers as photographer, writer, and part-time child and family counselor. I certainly had no thought of relocating to Saskatchewan or even of making the prairie a focus of my creative work.

I grew up in rural Quebec and subsequently lived on Canada's west coast for most of my adult life. Like many people, I simply overlooked the prairie. As my photography career grew from a hobby to a more dedicated, impassioned pursuit, I took every opportunity to head for the mountains. An incorrigible maker of lists, I can summon up the details of every major backpacking trip I did over a twenty-year period, from the northern section of the Pacific Crest Trail in Washington to British Columbia's wild and remote Wokkpash Gorge. I loved the high country and still do.

So why turn to the prairie now, in my midfifties? Chance. Serendipity, maybe. During a period of extreme upheaval in my life, I received

an invitation to spend a winter with Robert and Mette Ducan in Val
Marie, Saskatchewan, as artist in residence at their wonderful Convent
Country Inn.

Val Marie lies at the edge of Grasslands National Park, so the photo
potential would be huge. And Robert and Mette operate within a broad
spectrum of life's possibilities, so I knew this would be an interesting
place to spend some time. With little hesitation I accepted the offer
and subsequently navigated my Toyota Tercel through the swirling bliz-
zards and numbing cold of eastern Canada, the American Midwest,
and finally the vast, white, frozen prairie, blowing into the little village
ten days before Christmas.

Prairie in winter: what a subject for a photographer! Indescribable
beauty in the relentless grip of shattering cold. Eventually that fear-
ful grip loosened, and spring wafted in with its influx of birds and
resurgence of life; throughout the coming cycle of seasonal change it
never became boring, and I never regretted my choice to be there. Two
book projects sprang from my initial field work in Grasslands. My busi-
ness card soon would read "No fixed address—traveling somewhere in
North America." Very impressive. The truth and nothing but.

Despite recently returning to live in British Columbia, I know
that prairie is embedded permanently beneath my skin. I have never
encountered a more difficult or compelling subject to photograph. The
seemingly limitless spaces, huge skies, dramatic changes in weather,
and absence of crowds create a sense of place dominated as much by
imagination as by consensual reality: the prairie can be surreal. And

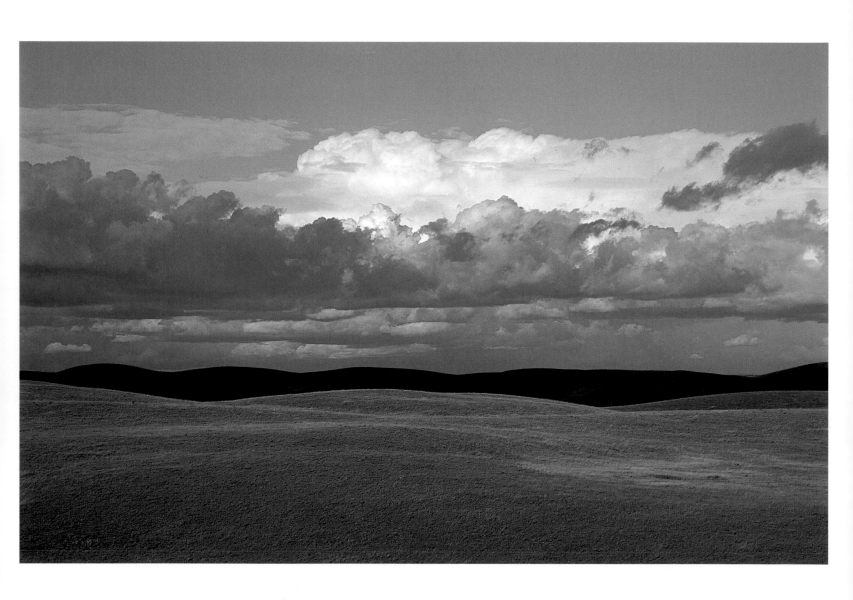

Preface

LEFT: *Cumulus clouds gather over short-grass prairie in southwestern Saskatchewan.* BELOW: *Warm light at dusk drenches the eroding slopes of 70 Mile Butte in Grasslands National Park, Saskatchewan.*

. . .

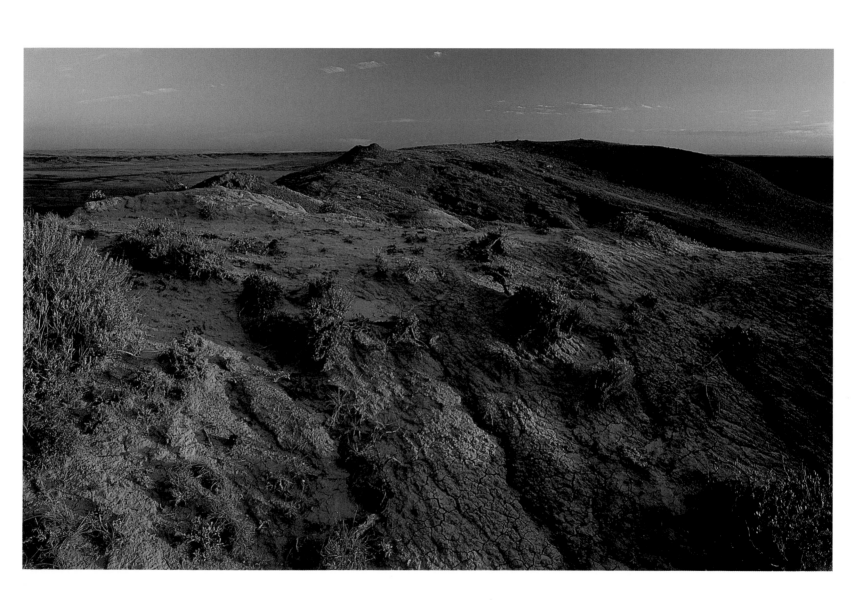

subtle. It does not jump out at you like the Grand Canyon, demanding to have its picture taken. You need patience. You need to give it time.

There are many ideas of what prairie is, what it might become, how it should be developed, and how it must be protected. Scientists are not all in agreement; nor are the farmers, ranchers, naturalists, artists, and other diverse groups who have concerns about the future of this great central grassland of the continent. This book focuses on the wild prairie. But what exactly is wild prairie? Can any surviving prairie lands really be called wild today, as we careen into the twenty-first century? Surely not agriculture-based land; farmed tracts of prairie lack the species diversity that occurred naturally. So much prairie has been lost forever to encroachment from civilization that remnants of natural prairie exist in only patchwork form in most regions of the Great Plains.

For this reason, I use the term "wild" in this book with some qualifications. No prairie wilderness remains, nothing remotely similar to the isolated, wild mountains of Alaska or the Yukon. You can disappear forever in that northern wilderness. On the prairie, however, you will eventually stumble out onto a dirt road, or into a barbed wire fence. Some contemporary explorers define wilderness as a place where you could be eaten; this is unlikely to occur on the prairie—at least, not while you are still breathing and squawking.

Nevertheless, in many prairie locations you can stand and survey terrain that appears much as it did three hundred years ago. It looks wild. It feels wild. True, tiny patches of native prairie exist, some smaller than a backyard, that will never again bear the paw prints of a red fox or

be infused with the trill of a meadowlark. And prairie-at-large will not experience again the thunder of tens of thousands of bison hooves.

This brings up an interesting point. Wild prairie was grazed prairie, specifically, prairie grazed by bison and pronghorn. Can ungrazed prairie, or prairie grazed by cattle or by managed herds of bison, still be considered wild? I submit that it can. Ranchers have been excellent stewards of the land. The impact from grazing cattle in the mixed-grass and short-grass prairie regions of the West over the past century has been minimal. It is easy to see that landowners in these parts love the prairie and have cared for it. True, the wildness has undergone major changes. But so long as the prairie contains most of the key species— grasses, forbs, lichens, mammals, birds, reptiles, amphibians, and arthropods—that are historically associated with the grasslands, and so long as it remains sufficiently large, robust, and uncontaminated to propagate, if abandoned, from its healthy roots and rhizomes and seeds, I believe we can continue to look upon it as wild. As the Zen master said, everything is in constant, flowing change.

Photographing the wildest portions of living prairie through all four seasons has meant seeking out islands of protected prairie in a sea of agricultural development. The distances between them are often huge. Driving the interstates and back roads, staying at countless motels and campgrounds, researching locations via the Internet, tracking down information—a great deal of preparation precedes an actual day of photography. Even so, sometimes the preparation goes out the window once I am on location. It isn't unusual for me to drive 600 miles only to find

BELOW: *Erosion has sculpted these badlands into fantastic forms at Toadstool Geologic Park in northwestern Nebraska.* RIGHT: *Tipi rings on the northern plains indicate centuries of human occupation.*

· · ·

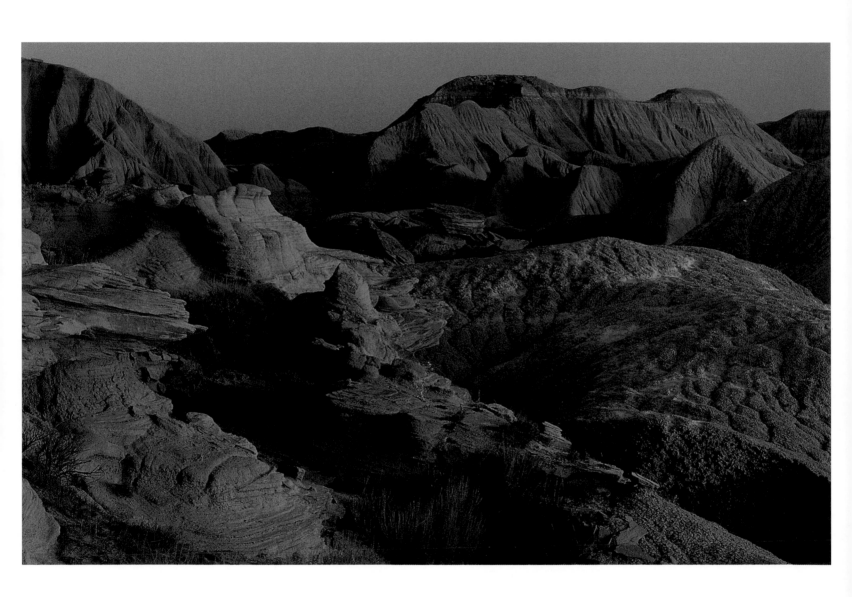

Preface

myself photographing water droplets on a leaf. If I am able to see the water droplets as a gift, not a limitation, my creative process becomes a true journey of discovery, unhindered by preconceptions. •

Fortunately, my pathway through the prairies has not been all travel and motels and brief visits to scattered locations. Any heart-centered work needs a physical place of grounding, and I found mine in Val Marie and Grasslands National Park. While compiling the photos and ideas for this project, I lived there, off and on, for nearly three years. It was possible to be spontaneous and get out on the prairie quickly if, for example, I happened to glance out my kitchen window and see dramatic weather rolling in. Convenience aside, the countless hours I spent driving the park roads and hiking into its remote corners allowed Grasslands to expand in my imagination; it came to represent for me the essence of the mixed-grass prairie, the landscape to which I would inevitably compare all others. It became my starting point and the familiar place to which I would return to rest and regroup.

I have not attempted to document every aspect of the prairies; it would be physically impossible to visit every prairie state and province in every season and complete the project in my lifetime. Instead, I offer a personal journey, a collection of photos, vignettes, and descriptions that capture the feel of prairie as I experienced it. Among the wildlife, landscape, and closeup photographs may be found some images that resist easy categorization. Stepping outside the box is my most satisfying experience as a photographer, and I think the prairie encourages such exercises in imagination. Immersed in solitude, the photographer

who can shake off the self-babble—that incessant, nattering inner dialogue—is free to discover the myriad components of visual design that exist everywhere in this stark, stunning landscape.

None of the images in this book were digitally manipulated beyond basic color balancing, contrast adjustment, and so forth—old darkroom tradition transposed to the digital era. All the wildlife species portrayed are "certified wild"—that is, photographed on location in their natural habitat, not in captivity. Grasslands National Park is an extraordinary location for wildlife; many of the representative species shots were made there. Because it was practically in my backyard, I had the luxury of repeated visits. I didn't get every wildlife species and behavioral sequence that I wanted, but any disappointment was balanced by unexpected surprises that regularly came my way.

I have generally used common names for the various prairie species and taxonomic names only when clarification seemed necessary—for example, when two or more common names for the same species are in widespread use.

Prairies are the most altered of North American ecosystems; there is no avoiding that reality. But rather than an exercise in nostalgia or a lament for a vanished world, these photographs are intended as a celebration of living prairie ecosystems that have survived down to the present day. Despite drastic changes over the past hundred-odd years, in the twenty-first century, prairie grasslands still exist to enthrall and educate those who choose to visit and study them in all their splendor and diversity.

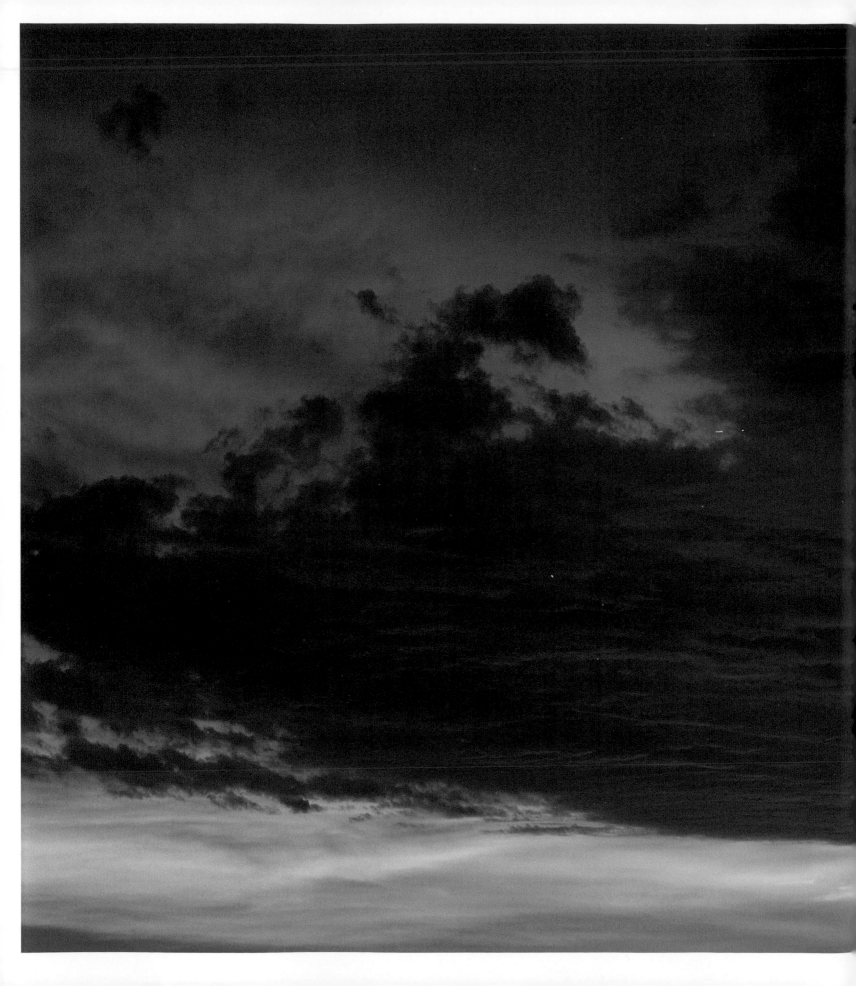

INTRODUCTION

IMAGINE EARLY DAWN on the prairie in northwestern Minnesota, the sun burrowing through thick fog like a lonely lighthouse beacon. Stands of big bluestem rise from the flat land, utterly still in the absence of wind: tall-grass prairie. Dewdrops cling to every surface, to strands of spiderweb that hang in weighted loops, to orange-and-black monarch butterflies dormant in the chilly air.

Everywhere you look, luminous in the soft light, are colorful midsummer wildflowers—pink prairie bergamot, purple coneflower, the first goldenrod blooms—nestled in a hundred tones of green. A flutter of movement catches your eye some distance away as a black-and-white bobolink skims over grass tops to perch briefly on a low shrub. Mosquitoes now rise to greet you, reminders that the tall-grass prairie is not

. . .

Turbulent clouds glow blood-red as the first rays
of dawn spread across the prairie sky.

These large concretions at Alberta's Red Rock
Coulee Natural Area were formed in an ancient seabed.

. . .

.

entirely benign. In a few weeks they will have disappeared, along with most of the flowers and birds, as the season begins tilting toward fall and then winter. For now, you are experiencing summer in the midst of a trace remnant of the native tall-grass prairie that our ancestors repeatedly called a sea of grass.

The analogy to ocean—featurelessness, vastness—was once obvious. Today, however, you need only backtrack on foot a few hundred yards to step into your car and rejoin the twenty-first century of highways, cities, and towns, and between them, great farm operations, corn or wheat to the horizon, monoculture at its most extreme. Everywhere prairies are contained. Native tall-grass prairie is like coyote voices riding a distant breeze—barely audible. It was not always so.

The lovely word "prairie" was bestowed by early French traders and voyageurs who explored the unimaginably vast and fecund grasslands of North America's interior in the 1700s. Together with similar ecosystems—for example, the steppes of central Eurasia and the savannas of Africa—they form Earth's great grassland biome. The North American prairie today is recognized by several distinct and defining characteristics; prairies are vast, flat, or rolling lands, mostly treeless, and dominated by grasses. And although prairies exist in such diverse locations as Washington State, Ontario, and Florida, most of North America's native grasslands are found on the Great Plains, roughly bounded to the north by boreal forest, to the west by the Rocky Mountains, to the east by hardwood forests (and industrial sprawl), and to the south by deserts. Prairies therefore occupy a huge chunk of the continent. They

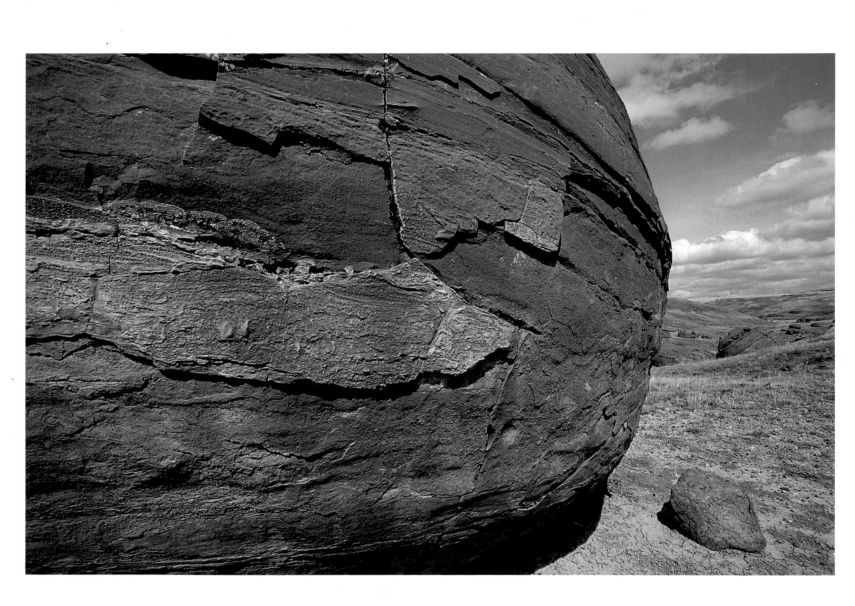

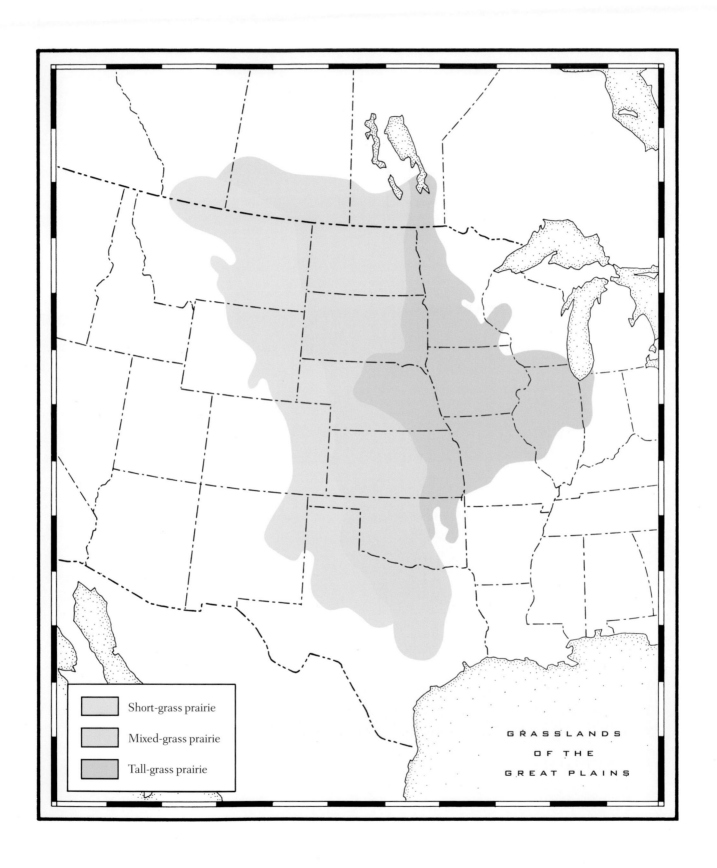

Short-grass prairie

Mixed-grass prairie

Tall-grass prairie

GRASSLANDS
OF THE
GREAT PLAINS

comprise 15 percent of the land area of North America, encompassing nearly 1.4 million square miles and stretching across the plains from central Saskatchewan to southern Texas and from western Indiana to the Rocky Mountain foothills (see map).

Emerging from thinning forests of oak and hickory in the eastern portion of the Great Plains, nourished by rainfall and rich soil, tall-grass or "true" prairie once occupied large tracts of land both east and west of the Missouri River. Today only a fraction remains—less than 4 percent across the United States and less than 0.1 percent in Iowa. This most biologically diverse of North American prairie types gives way in more arid central regions to the mixed-grass prairie. Here, cacti and rattlesnakes flourish, and trees survive only in the most sheltered coulees, where folds in the earth provide some protection from the desiccating wind. Drought occurs periodically—in both central and western regions of the Great Plains, rainfall can be as little as 12 inches or less per year. (The dust bowl of the 1930s was largely the result of attempts to impose old, inappropriate farming practices on this unforgiving and unpredictable land.) Finally, in the Far West, ranges of short-grass prairie abut the mountain slopes. Winter snowstorms come early here, in the rain shadow of the Rockies, where shorter summers and thin, rocky soils produce only a sparse grass cover and ranching generally is more widespread than farming.

Looking out across the prairie today in a typical location—say, northwestern Minnesota—from a hilltop viewpoint (they do exist) and a perspective that doesn't include highways and interstates (not so easy),

Ripples on the shifting dunes at Monahans Sandhills
State Park, Texas, lie under low, slanting light.

. . .

one has difficulty imagining these lands being anything but placid and settled. Yet there has been turmoil here, both geophysical and cultural.

Four hundred million years ago, a shallow inland sea covered much of central North America. Its levels rose and fell with successive incursions of water from the Pacific interspersed with periods of drying. Within about a hundred million years, the sea had shrunk into a boggy, swampy terrain that gave rise to giant ferns, coniferous forests, and a host of newly proliferating land animals. Dinosaurs arrived, flourished, and disappeared suddenly in the great extinction approximately 65 million years BP. Meanwhile, occasional flooding had continued throughout the continent's interior until the uplifting Rocky Mountains became sufficiently massive to cut off further influxes of ocean water. As they grew, these new mountains drained most of the moisture out of cloud systems traveling east from the Pacific. About 37 million years BP a worldwide cooling trend, in combination with reduced rainfall over the central plains, allowed drought-resistant grasses to replace trees as the dominant plant of the region. Thus, a mere 20-odd million years ago, recognizable prairies finally came into existence.

Successive ice ages featuring massive glacial advances and retreats further shaped these newly formed grassy plains, gouging prairie potholes and dropping huge boulders called glacial erratics. As the glaciers retreated, melting ice gave birth to the great rivers that now drain the Rocky Mountains east of the Continental Divide, among them the Missouri, the Yellowstone, the Platte, the Saskatchewan, the Frenchman, and the Milk.

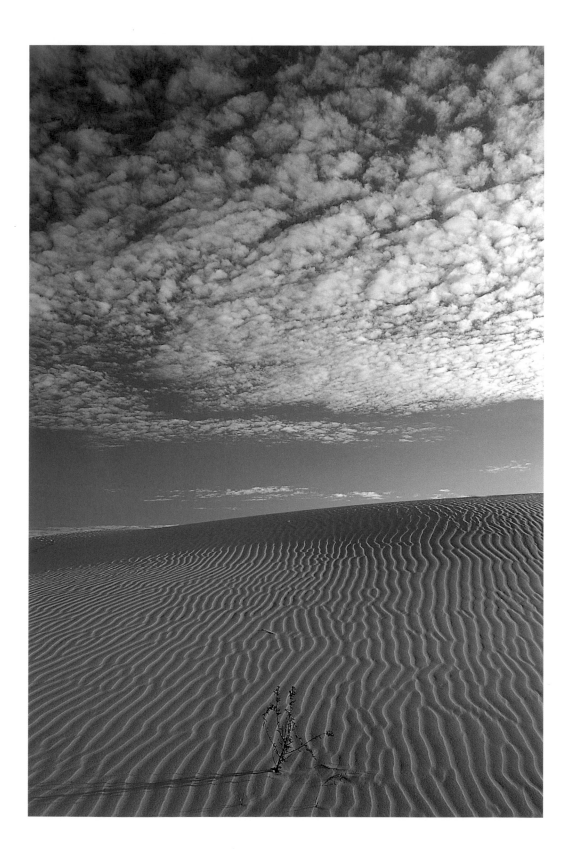

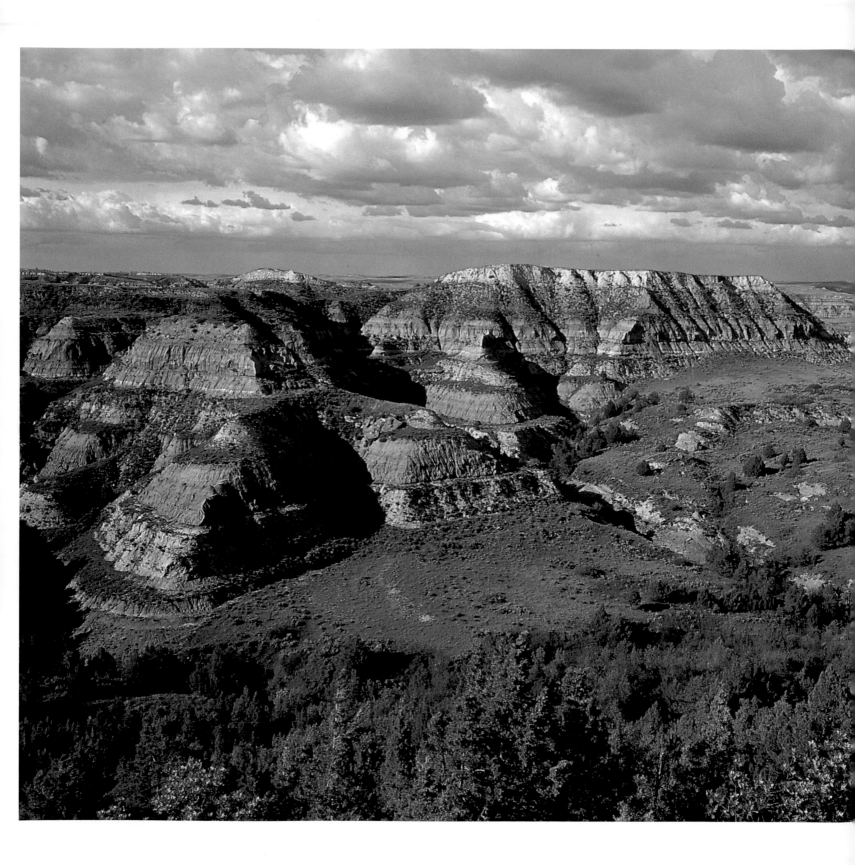

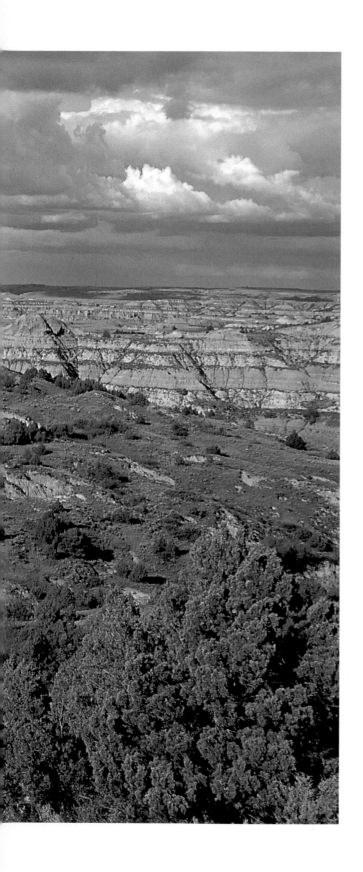

LEFT: *A rare mantle of green covers the badlands after spring rain, Theodore Roosevelt National Park, North Dakota.* ABOVE: *Blue grama grass waves in a summer breeze.*

· · ·

[21]

Mineral deposition, drainage patterns, climate, and many other factors have led to variations within the three general types of prairie. Tall-grass prairie in the Flint Hills of Kansas and Oklahoma, for example, is very different from the oak savanna and sandhill prairie of northwestern Minnesota. Both are tall-grass, featuring typical grasses such as big bluestem. The Flint Hills, however, are as stony as the name implies, whereas portions of Minnesota that once lay submerged beneath the immense body of glacial meltwater known as Lake Agassiz have developed into an ecologically rich landscape of undulating, grass-covered sand hills.

Archeologists continue to investigate and debate evidence of human occupation in North America; currently, the best estimate has nomadic Asians crossing the Bering land bridge between 15,000 and 33,000 years BP and entering the continent either along its west coast or through ice-free zones in the interior. The grasslands these wanderers inherited when the ice retreated and, much later, dominated so skillfully from horseback for a brief flash of time may have contained the greatest proliferation of grazing wildlife in Earth's history. Plains Cree, Assiniboine, Blackfoot, Mandan, Lakota, Cheyenne, Pawnee, Kiowa, Comanche, and many other tribal groups successfully occupied the prairie for varying lengths of time, leaving behind burial cairns, vision quest sites, buffalo jumps, medicine wheels, and thousands of tipi rings—circles of stone that once held the skin coverings of their lodges in place. The diameter of these rings is a guide to their age. After the arrival of the horse on the northern plains in about 1735, people could

pack heavier loads on their travois, which had previously been pulled by dogs—or women. Larger rings indicate larger tipis and tend to be more recent, postdating the horse.

This nomadic life must have been hard, especially before the acquisition of horses. Stalking bison or antelope in the open, on foot, would have required tremendous skill as well as knowledge of animal behavior. Excavations show that some buffalo jumps—steep cliffs over which bison were stampeded—were in use for thousands of years. The carefully selected terrain was often a flat stretch of prairie sloping slightly uphill toward the cliff edge, so the onrushing, panicked animals could not see what lay ahead. Men and women alike would shout and wave robes, sometimes using boulders to create drive lanes. At the base of the cliff, where hunters would wait with bows and spears to dispatch wounded animals, the din and dust and scent of blood must have been overwhelming. In later years, hunts were more often conducted on horseback. The horse became a primary symbol of independence for most plains tribes, as well as a coveted trade item and a measure of a hunter and warrior's personal achievements. Raiding horses from enemies became commonplace. Warfare consisted mostly of small-scale, ritualized encounters.

Until the mid-1800s, pressure on the Native inhabitants of the plains gradually increased, mostly because of resource exploitation by fur traders, notably the Hudson's Bay Company in Canada and smaller but no less voracious enterprises in the United States. Smallpox epidemics introduced by these newcomers wiped out entire villages. If

A buffalo rubbing stone in summer (BELOW) and again in winter (RIGHT) at Grasslands National Park, Saskatchewan. Generations of bison hooves have left a shallow depression in the ground still visible today.

. . .

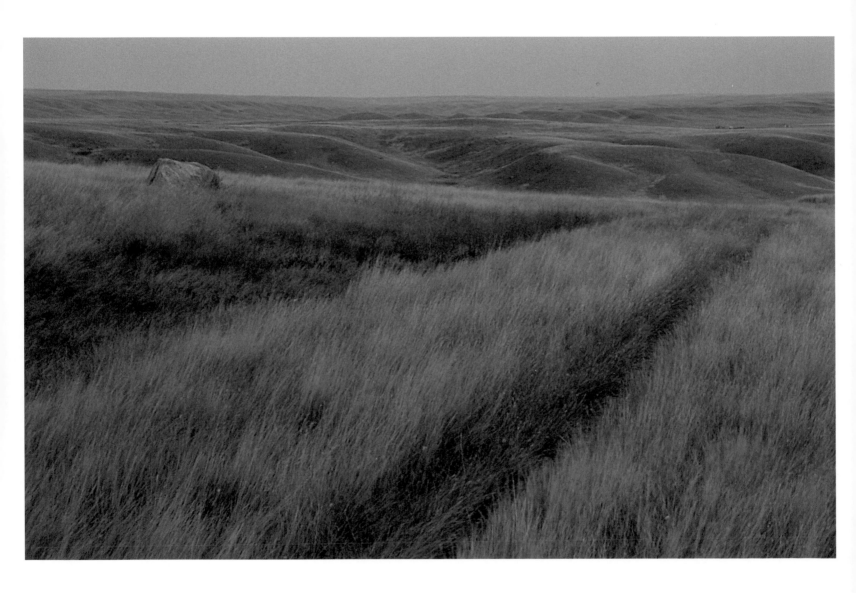

Introduction

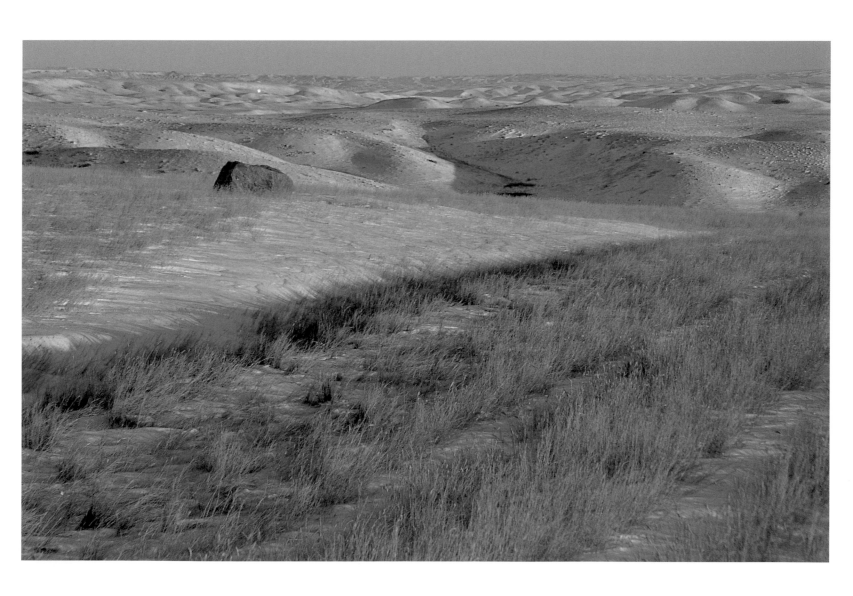

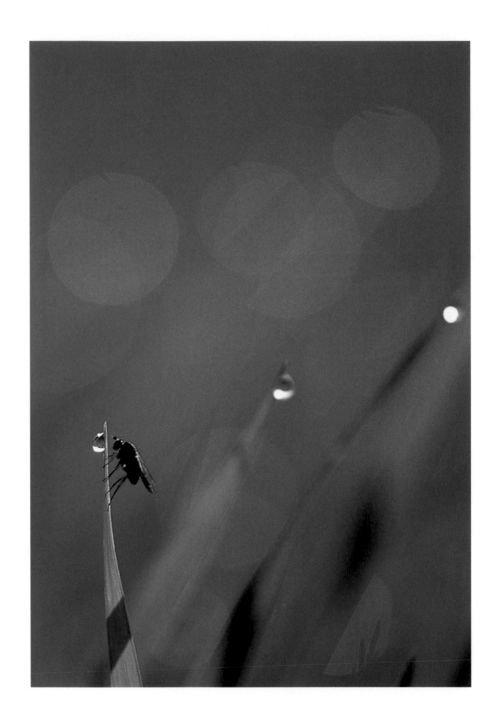

Introduction

. . .

guns and iron tools were useful additions to the lives of Native North Americans, alcohol contributed to the increasing level of violence on the frontier, both in white and indigenous communities.

Following the American Civil War, white settlers poured into the lands west of the Missouri en masse. What could hold them back? The tall-grass prairie, springing from deep and fertile soil, was easily broken by the plow; it fell as surely as the great firs and cedars of the West Coast would topple in future decades. Bison were driven nearly to extinction and replaced by cattle, lesser, more easily managed beasts. By the early twentieth century, fences partitioned off the last open ranges of the wild West; in a generation it was gone. Since then, the remaining, renegade pockets of wild prairie have been steadily whittled away.

The tall-grass prairie that dominated the eastern portions of the plains was virtually eradicated. Only isolated patches of it remain intact, in Manitoba, Minnesota, Iowa, Nebraska, Kansas, Missouri, and a few other states. Much of the native prairie found today in parks and preserves has been reclaimed from land previously cultivated. Inevitably, its character has changed.

Fragmentation of native prairie has changed a continuous landscape into a threadbare patchwork. Loss of native species is a continuing problem, and indigenous plants must now compete with many introduced and invasive species. Funding for conservation of native prairie often falls far short of requirements. And the three major forces that historically contributed to ecological balance—fire, grazing, and climate—have been changed themselves in significant ways.

A great horned owl pauses at dusk in the
window of an abandoned shed.

. . .

Wildfires revitalize plant growth by removing dead vegetation. They are rare on grasslands today; fire was a real threat to the first settlers, and their habit of putting them out continues. There is evidence that Native peoples in some areas regularly set the prairie on fire and that they taught this practice to Kansas ranchers, who use it to this day. In most places, however, the practice was ignored, and park managers have only recently seen the value of prescribed burns in restoring prairie ecosystems.

Grazing patterns have also changed. Bison were migratory animals; they might heavily graze and trample a section of prairie and then not return for seven or eight years. Thus, the churned-up ground would have an opportunity to regenerate, fertilized by scat, while seeds transported on shaggy coats could sprout in new locations and contribute to the proliferation of plant species. The impact of migratory grazing is somewhat different from that of cattle moving about on microranges year round. With cattle, there is less recovery time for the grass; even the most eco-sensitive, seasonal grazing cannot exactly replicate the natural order. And when native grasses are phased out in favor of introduced species deemed more efficient at being transformed into animal protein, biodiversity is lost. Just as a tree farm is not a forest, grazed pasture is not natural prairie.

The debate about climate change rages today, but there is a growing consensus that global warming is real, its eventual impact unknown and potentially cataclysmic. Can an already arid prairie withstand a temperature increase of even a few degrees and still be recognizable as

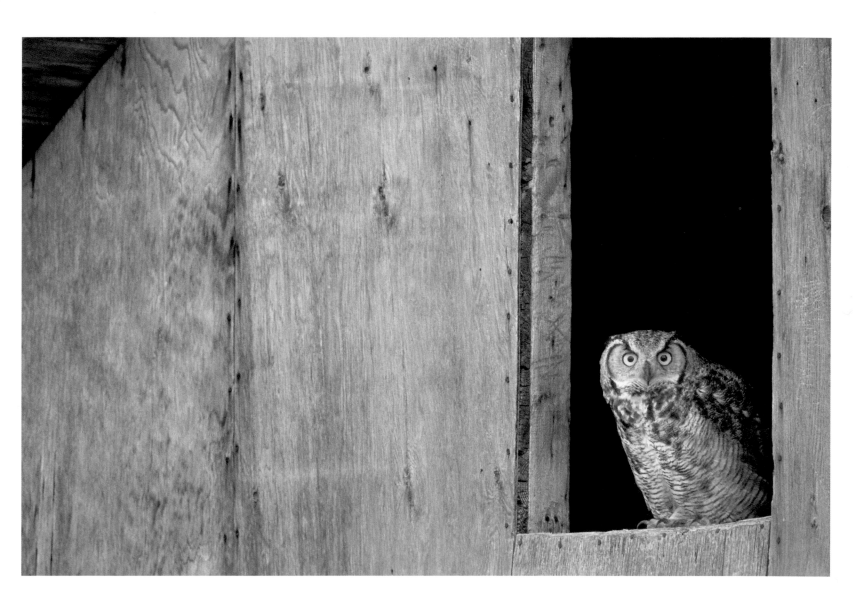

prairie? Probably not. We must expect a good percentage of the prairie to become desert unless the present global warming trend can be significantly altered.

A good argument, therefore, can be made that the prairie that nomadic First Nations people and early settlers knew no longer exists. Range managers and custodians of park lands know that they cannot reclaim the past; in most cases, their goal is to restore prairie to its greatest possible level of health. At Theodore Roosevelt National Park in North Dakota, for example, you can see free-ranging herds of bison against a spectacular backdrop of badlands and prairie grasslands. But there is by necessity a perimeter fence. Bison are big, unruly beasts that can wreak havoc on agricultural property. A limitation therefore exists, defined by the reality of the surrounding private lands and perhaps by our internal conflict about how to fairly assess abstract, intrinsic value against measurable economic value.

Walk out onto the grasslands, alone, in the wind, beneath the sky. There is power here; you can feel it. Earth, sky, and power. You encounter it in the dramatic thunderheads, the battering rain and hailstorms of summer, even in a rainbow sprouting serenely from the carpet of grass in the wake of furies unleashed. Even in the absence of storms, there is a powerful presence on the prairie: you can find places to stand, surrounded by waves of wind-hammered grass—waves of grass! Look to the horizon, a vista with no roads or houses, nothing to spoil the view or pull you mentally and emotionally back to the mechanized, electronic modern world. There's just you and that great bowl of

sky and the textured ground at your feet. Exactly what your ancestors would have seen had they ventured here.

Everything on the prairie seems either huge or impossibly small. The trick of scale plays out repeatedly. Without trees, without visual anchors, you might experience an eerie sensation, as if the ground underfoot were a treadmill. Start walking across a flat-bottomed valley toward a far ridge, and you can quickly lose track of time, distance, proportion, and purpose. The horizon is a distant line, a mere abstraction, shimmering in the heat. Unreal. You are nothing. You must maintain a sense of humor. Look down. Beneath your boots, something more of this world, blue grama grass and pincushion cactus, the latter bursting briefly with magenta blooms. A dung roller beetle pushes a rabbit pellet across dry ground. Grasshoppers fidget, shifting to the far side of grass stalks, hiding, watchful. You are here, now. Smiling.

If you spend a year here, one swing through the seasons, you cannot emerge unchanged. (A lifetime would be better, but a year will do.) Whether surveyed from a height of land overlooking countless miles of terrain, or examined down on hands and knees where eternity may be found in a rabbit pellet or a seed of grass, the prairie grasslands are a wonder to explore—and a treasure worth preserving for future generations.

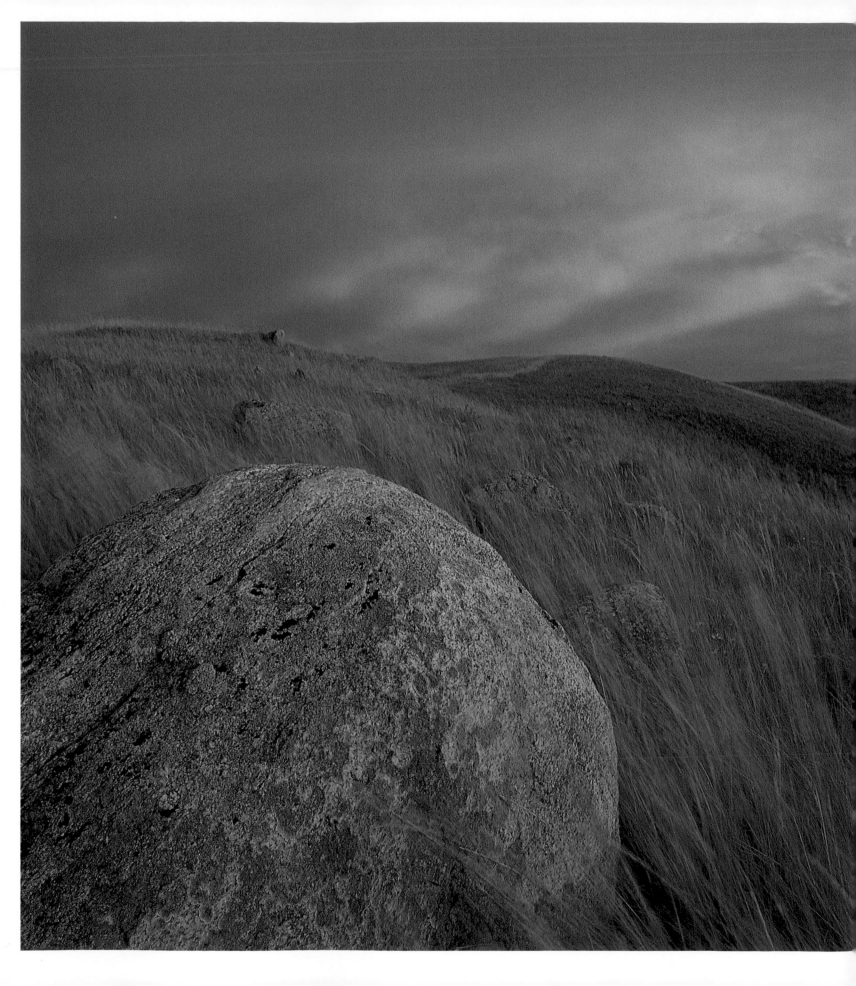

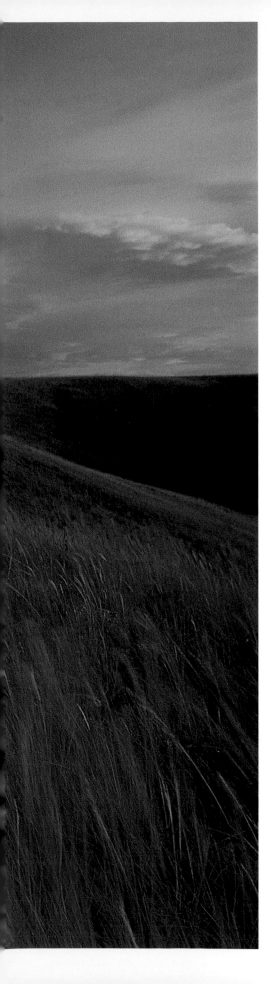

SUMMER

SEASON *of* FIRE

DISTANCE ROLLS BY beneath my tires. It's a long, long drive from Saskatchewan to Kansas in the first full heat of summer, early July. I notice a palpable change in the air when I reach northeastern Nebraska, corn country, rich soil upon which to stake a future. This prairie is lush compared with the arid country I've just left; there is humidity here, a heavier warmth, and a greenness to the landscape. At its peak of growth, production, and proliferation, summer seems to have the prairie firmly in its grasp.

Farther south, Kansas is hot. Every afternoon the mercury climbs above 95°F. This is a season of fire, needed warmth taken to extremes. The sparse shade available in campgrounds has been snapped up by others, and the remaining spots are like a griddle. I end up taking

· · ·

A warm summer evening unfolds in the Frenchman River Valley, Grasslands National Park, Saskatchewan.

[33]

Harebells wave in tall-grass at Bluestem
Prairie Scientific and Natural Area, Minnesota.

. . .

a series of motel rooms with jarringly cold air-conditioning, not my pre-ferred habitat. I contract a sinus cold that muffles my sensory aware-ness, makes my head thick, my legs heavy. Nevertheless, I am on location at last and seem to be able to function. The early mornings are refreshingly cool. Close at hand is the Konza Prairie Research Natu-ral Area, a prime piece of tall-grass in the Flint Hills. Owned by the Nature Conservancy and operated as an outdoor laboratory by Kansas State University, Konza exists as a microcosm of living prairie, part of the tiny fraction of original tall-grass that has not been usurped by the food production industry.

A trail leads from the parking lot through shady woods of chinqua-pin and bur oak, elm, walnut, and hickory, across placid little Kings Creek and up a gentle slope toward viewpoints overlooking the Kan-sas River Valley. As I hike, I notice the intricate and interlinked plant communities surrounding me: the grasses, wildflowers, woody plants, mosses, and lichens. Many species are different from those in the mixed-grass prairie I've just left; among the ones I recognize are wild licorice and echinacea, or purple coneflower. My trusty prairie plant guide points to butterfly milkweed, blue vervain, and others new to me. They intermingle in a heady swirl of color and fragrance, a flurry of butterfly and bee activity. I get out the macro lens and make closeups of flowers for a while, but my curiosity bends more and more toward the grasses; after all, what plants better epitomize these prairie lands? It seems grasses are closer to the heart of the prairie, the essence I'm trying to distill on a few rectangles of film stock.

Summer

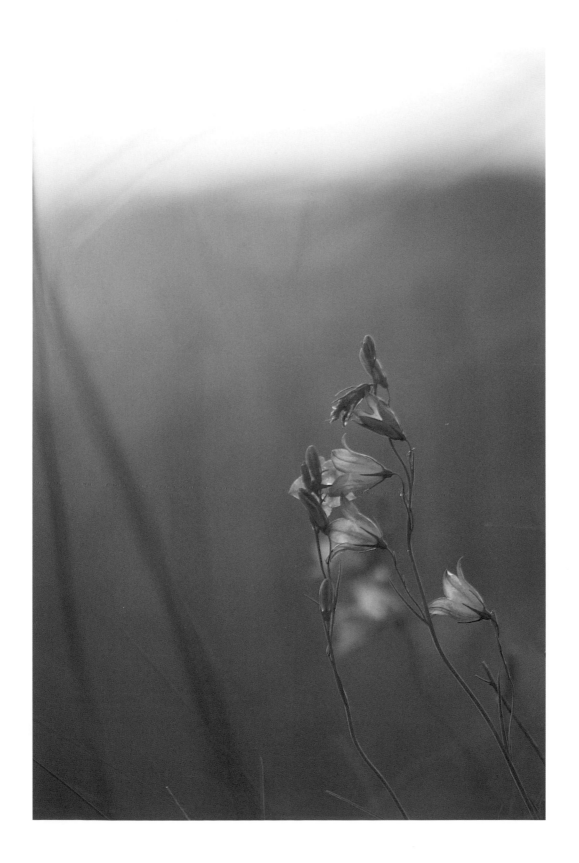

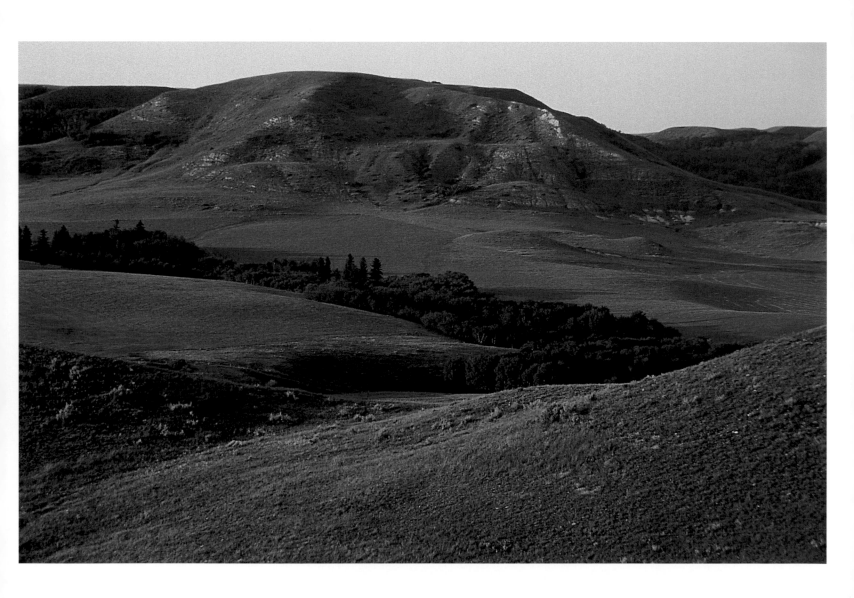

Summer

Defined this way, my task as a photographer seems more than a little contradictory: to try to capture the essence, the heart of the matter, using light reflected off its surfaces. Yet even these available surfaces are in a way deceptive: prairie, especially tall-grass prairie, locks away most of its secrets. Beneath the surface is the place where most life processes go on in the prairie biome. Down there in darkness, amid the thick tangle of roots and rhizomes, is an astounding world of microbial activity, insect life cycles, burrowing mammals and reptiles. This lightless world is beyond my reach; vivid imaginings do not imprint on film. I am stuck in the sunlit world of grass stalks and sky, the surface fringe.

Crawling through this fringe in the warming air, I am struck by the species diversity evident in a relatively small area. The grasses that inhabit rocky outcrops, for example, are clearly different from those with roots sunk in the deeper, moist soil of valley bottoms. On the dry ridge I find a familiar grass, blue grama, characteristic of southwestern Saskatchewan, where I live; apparently some plants of the mixed-grass prairie can thrive here in the Flint Hills. Among the species commonly associated with tall-grass, I find Indian grass and big bluestem. I know the latter, having encountered it previously in the Manitoba Tall-Grass Prairie Preserve, just north of the border with Minnesota. In the pervasive heat, these stalks are already 20 inches or more above ground; soon their flowers will begin to develop.

Big bluestem is an amazing grass. Prolific and widespread, considered the signature plant of tall-grass prairie, it can reach a height of

more than six feet by late summer, yet its root system is even more impressive, reaching down into the soil twice that distance. Following the drought years of the Great Depression, this plant regenerated, seemingly against all odds, from roots that had remained alive far beneath the depleted and parched topsoil. When the rain finally came, new shoots began poking up through the prairie earth. Through many seasons of fire, seasons dry beyond expectation, these plants had managed to survive. *Luctor et emergo!*

By late morning, the high-arcing sun has flattened out the light, paled the colors, created a visual world of harsh contrasts. Meanwhile, temperatures have begun to soar. When the mercury hits 95°F, I have to pack it in. Stumbling back to my car, I notice four or five wild turkeys scurrying away from me, through a clearing and into shady woods, and later I glimpse the ears and red-brown coat of a white-tailed deer, watching and listening from deep shadows. Not much happens at midday in the burning prairie summer. Animals tend to be most active at night or—like me—at dawn and dusk. Only the insects and a few reptiles appear to thrive in the searing heat of high noon.

Poring over maps of the Prairie states and Canada's three Prairie provinces, I can identify many small prairie preserves that may be worth visiting. Sadly, the key word is "small"; nowhere is there a vast expanse of tall-grass such as early explorers gazed upon. I visit Cayler Prairie in northern Iowa, where less than 1 percent of that state's original 30 million acres of native tall-grass remains intact. I want to portray this ecosystem as I see and feel it: fragile, colorful, varied. Once

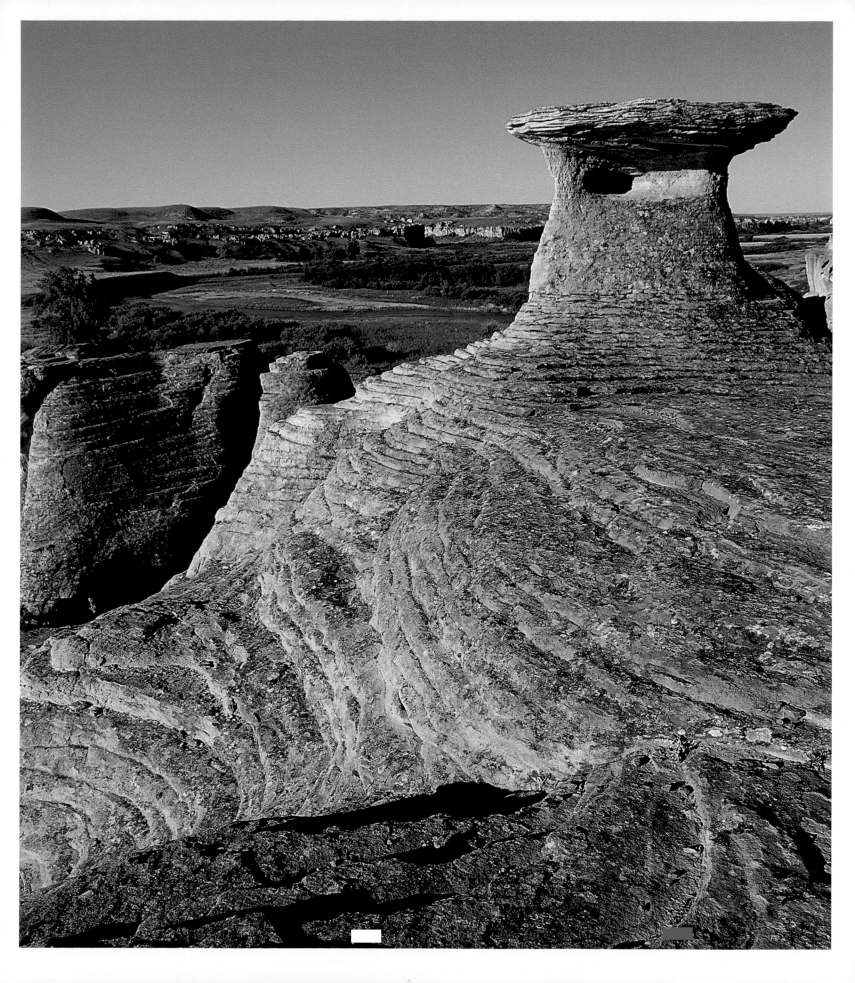

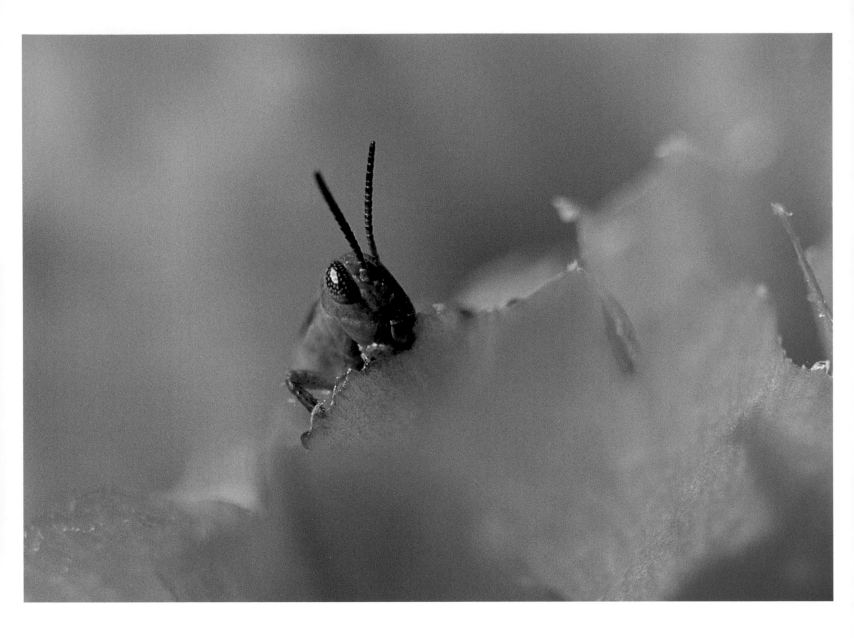

Summer

upon a time it was also vast. If vastness is one of the definitions of true prairie, what am I really looking at? From any hilltop here I can see farms and cows. Walking across the undulating terrain, the only visitor on this sweltering summer evening, I struggle with the question of whether tall-grass prairie really exists at all as a living entity. Can an ecosystem no longer intact be celebrated without cynicism? I decide I must celebrate it anyway; cynicism has no place in my work. Besides, there is beauty in the microcosm. And grasses, those hardy survivors of ice and drought, of desiccating winds and sweeping wildfires, could win in the long run. Tall-grass prairie won't make a widespread comeback in my lifetime, but a human life span is short, and the grasses can wait.

Minnesota has larger tracts of protected tall-grass; for example, at Bluestem Prairie Scientific and Natural Area, near Moorhead, some 2,855 acres have been set aside. I time my arrival for the hour before dawn. Once again, I find myself alone in a beautiful prairie preserve. It feels good, too, to have left that eyeball-melting heat behind, and entered a gentler, more inviting world. Every dozen steps reveals a new, delicate expression of prairie fecundity: owl's clover, western red lily, harebells bathed in honeyed light, morning sun spreading like liquid through wind-rippled stands of bluestem. At noon the developing cloud cover has taken over the sky and begins to spit rain. I have been lying prone to photograph *Geum triflorum,* a plant known in Canada as three-flowered avens and in the United States as prairie smoke (an altogether more poetic label). Lost in a world of minutiae, I haven't

*The Nuttall's cottontail ranges across
sagebrush prairie and wooded uplands from southern
Saskatchewan to northern New Mexico.*

. . .

been watching the sky. Now as I hike back to my car, the first lightning forks above the northwestern horizon—a reminder that where there's smoke, there usually is fire.

Summer. Season of fire. In this most volatile of prairie seasons, thunderstorms can build up slowly over the course of an afternoon or form squall lines that sweep across miles of open ground at breathtaking speed, bringing pounding rain, shockingly cold wind, even hail. To stand on the exposed prairie and feel the plunging temperature and rising wind of an advancing storm is to feel your vulnerability, your smallness. Lightning close by can be terrifying. To photograph it, I have driven to the edge of many electrical storms. Once I miscalculated and blundered into the center of a huge and violent prairie holocaust. Blinding flashes of lightning, striking all around and arcing overhead, soon reduced me to a whimpering, babbling fool as I raced for home in my car, fully expecting my life to end at any instant. (It occurred to me later that, protected by the car's metal frame, I could survive a direct hit—only to end up blind, deaf, and impotent.) But I lived, the terror now a half-funny memory, still vivid but also somehow unbelievable.

Lightning has long contributed to the ecological health of prairie lands via the wildfires it touches off. Don't get caught near a prairie grass fire. It can travel up to 600 feet per minute and burn as hot as 700°F. Fires started by lightning strikes regularly burned portions of old prairie, thereby making way for new growth, much as a forest fire clears away the clotted debris in a stand of old growth and initiates the cycle of rebirth and regrowth. In eastern portions of the prairie, where

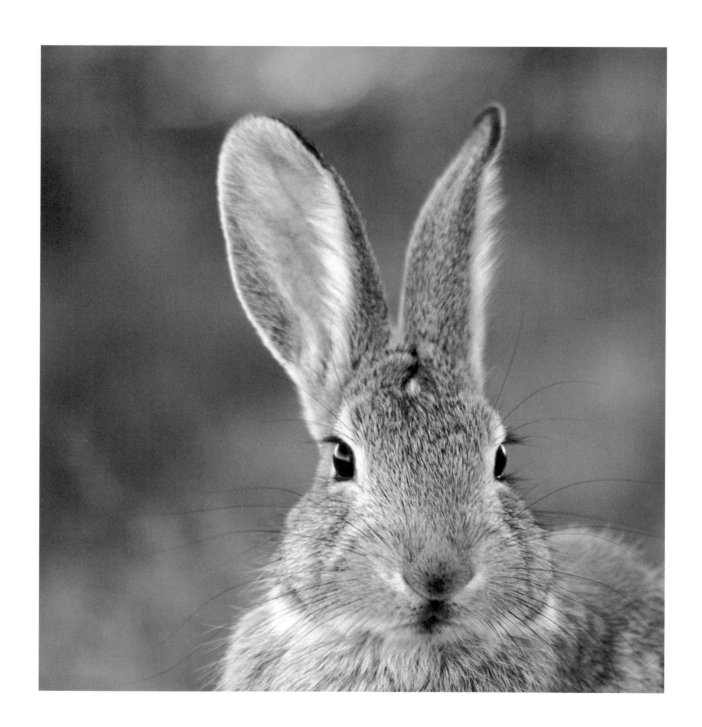

wildfires have been controlled by humans for a hundred years or more, incursions of oak and hickory woodland have gobbled up grasslands; to the north, the same pattern is evident in the spread of aspen park land. Trees are the true enemy of grass. Fire, once seen as an enemy, is now increasingly recognized as a friend of the grasslands. Range and park managers on both sides of the U.S.–Canada border are experimenting with controlled, prescribed burning in an attempt to replicate the effects of natural grass fires. In some places, too, fire is used to reduce the impact of invasive or introduced species that compete with native vegetation; the burned-over areas are then seeded with indigenous species. Regardless of the degree of success they achieve—unknown at present—it is clear that wildfires will never again occupy their former role as random, vital regenerators of prairie ecosystems.

As summer rises toward its apex, the prairie emits a constant background hum, a buzz of vibration that intermittently breaks through and into a visitor's consciousness. In the hot sun, grasses are starting to burn to yellow-brown. After a stifling hot afternoon, cool breezes from the west bring a hint of their mountain origins and a respite. An evening comes to mind, of golden light and soft July winds across the sparsely grassed and flowered slopes of Eagle Butte, in Grasslands National Park, Saskatchewan—one of those sweet times of nearly total immersion in a landscape. The air is thick with fragrant sweet-clover. My partner, Arlene, and I hike up a dusty ridge in the late afternoon. The short uphill grind terminates at a sweeping view of rugged badlands and coulees to the northeast, wheat fields and scattered ranch houses to the

south and west. Flat-topped, steep-sided 70 Mile Butte dominates the southern horizon. It is the highest point in Grasslands and in fact the highest point of land between the former North West Mounted Police outposts at Wood Mountain and the Cypress Hills—a landmark relied upon by travelers of every description when the country was opened up to ranchers and settlers in the late nineteenth century.

On this evening I am struck by a feeling that as prairie summers go, this is it: the peak, the culmination of another year. It doesn't get better. Butterflies flutter along the ridge. During the hour before dusk, we see several mule deer and one pronghorn make their way from the bottomland of Aspen Coulee to cross over a high, flat ridge known as the Tabletop and disappear into the maze of dry gullies on the other side. A nearly full moon glides up from behind 70 Mile Butte just as the last sunset light drenches the land in hues of red, glowing brighter as daylight fades. Overhead, we can hear the dry rasp of common nighthawks taking flight to wheel and dance the breeze, capturing winged insects by the hundreds. Stars wink into being. We hike down in the dark, quiet and content.

I did not see much wildlife on my visits to the tall-grass, aside from birds and insects. Habitat loss has affected numbers, especially of the larger mammals. Farther west, where larger tracts of land have been spared or reclaimed—in places such as Grasslands—wildlife is more evident. Before I lived in Saskatchewan, I had no idea of the wealth of wildlife inhabiting prairie lands. In the mixed-grass prairie, people often make their living by combining cattle ranching with wheat farming or

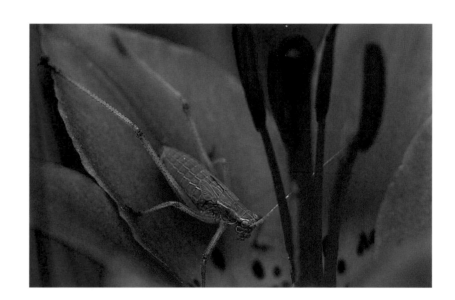

LEFT: *Dark ironstone fragments are scattered across pale sandstone in the fossil-rich badlands at Dinosaur Provincial Park, Alberta.*
ABOVE: *An immature katydid rests on a western red lily in tall-grass prairie, northwestern Minnesota.*

. . .

Prairie lands are mostly arid.
BELOW: *Cracked mud in Saskatchewan.*
RIGHT: *Fractured rock in Alberta.*

· · ·

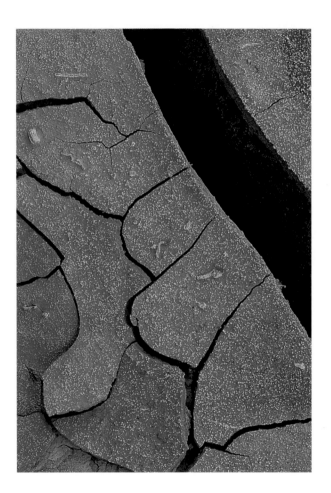

Summer

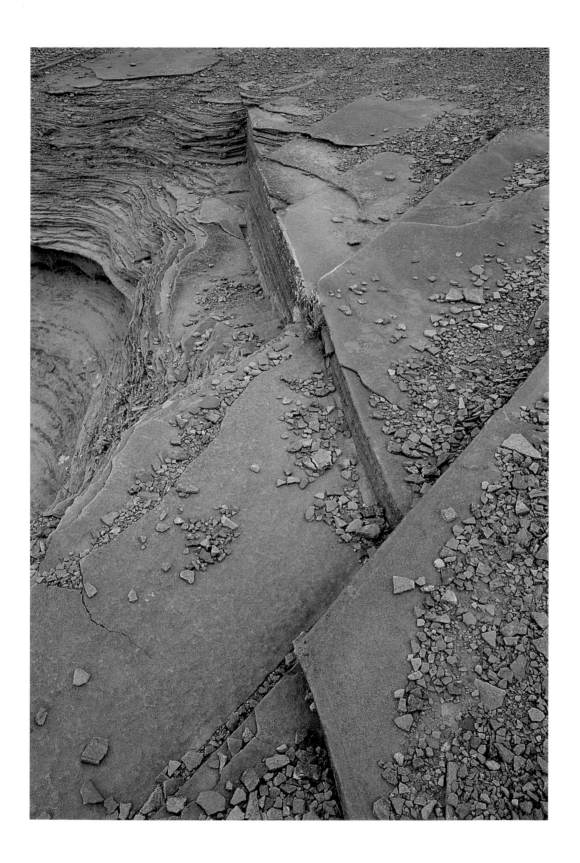

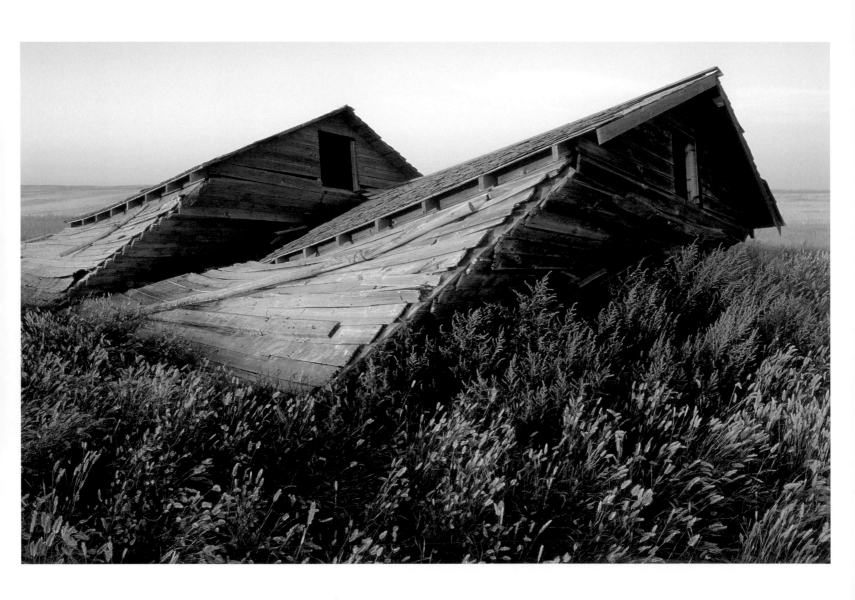

Summer

*The restless prairie wind
has nearly leveled these sheds near
Val Marie, Saskatchewan.*

. . .

with raising other crops, such as flax, canola, chick peas, and barley. Thus, within a large range there are plentiful food sources for grain-eating animals—and their predators. A food chain of prairie wildlife may extend from grasshoppers to ground squirrels to rattlesnakes to golden eagles, from deer to coyotes—and so on.

As a photographer, I like to go into the field with an open mind—in fact, with a mind as empty as possible—to be receptive to the unexpected gift, to not limit my creative eye with too many preconceptions. Often I have no idea whether I'll be shooting lightning or lichens on a given outing. A good proportion of my wildlife photo ops come by chance. When I discover a reliable or likely location for a given species, however, I will return to this place repeatedly.

In Grasslands National Park, there is a dome-shaped boulder on a hillside that I have visited for three summers in a row to photograph the prairie rattlesnakes usually found under it or nearby. Occasionally there have been one or more big, beautiful bullsnakes *(Pituophis melanoleucus)* in the vicinity. On hot summer days, these snakes like to rest in the shade of their rocky overhang; in slightly cooler weather, they may bask in the direct sunshine. Despite my initial wariness, I have learned to be fairly comfortable in their presence, to see them for what they are: shy, retiring creatures who don't want to be stepped on.

Lying prone on the rocky ground to photograph venomous reptiles would not be on everyone's list of favorite activities, but my only discomfort comes from an occasional cactus thorn in the hand, knee, or butt (not as funny as it sounds). For most wildlife photography, there's

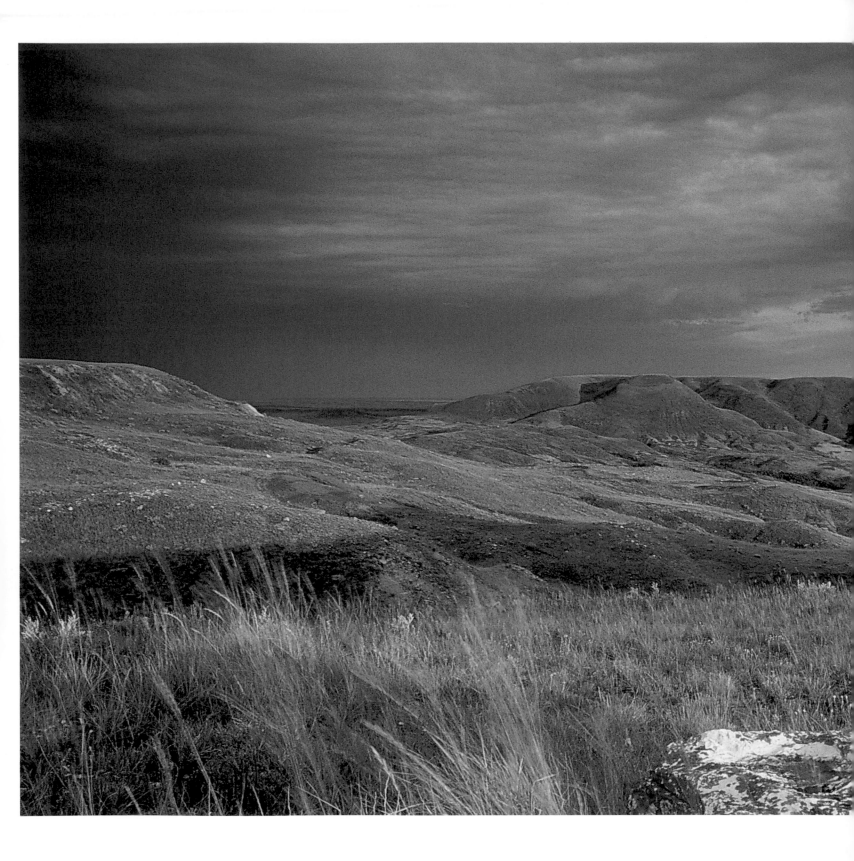

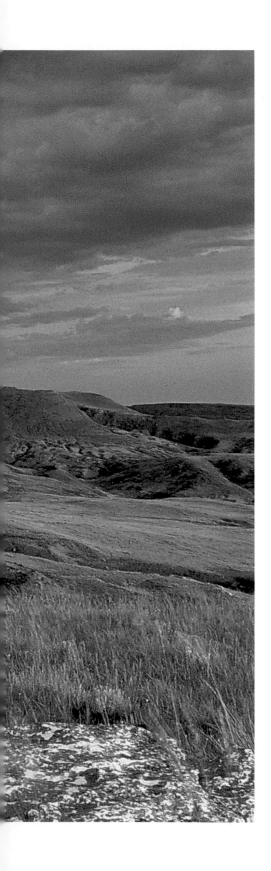

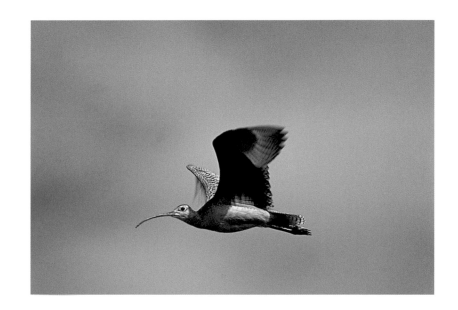

LEFT: *At the height of summer, the Tabletop and 70 Mile Butte bask beneath an evening sky in Grasslands National Park, Saskatchewan.* ABOVE: *The long-billed curlew breeds from southern Canada to Texas.*

. . .

A glacial erratic, dumped by
retreating ice age glaciers, rests among prairie
grasses on the northern plains.

. . .

nothing better than a low angle of view. To create a sense of inti-
macy, you must show the animal at eye level, down where it lives. Also,
down low, a human appears less threatening and therefore has a bet-
ter chance of keeping the encounter going, not frightening the subject
away. By approaching very slowly, inching my tripod across the ground,
I can often convince the snakes to accept my presence. At times they
coil and rattle, but usually they settle down if I don't make sudden
movements. A rattlesnake can strike about half its own body length,
and doubtless there have been instances when I have encroached on
this zone. But I have never been bitten. The only snake to strike at
me was one I had just removed from a road to the safety of a ditch by
flipping it with a stick; I was surprised by my own lightning reflexes
and agility in leaping backward to get out of range.

The rattlesnakes at Grasslands were a pleasure to study close up.
Among other small wildlife subjects I frequently photographed were
grasshoppers and katydids. In August grasshoppers can be a prairie
scourge. Having no direct investment in the edible products of this
land, I am able to look upon them as simply another wildlife species
to photograph, but I know that farmers feel altogether differently.
I have been asked more than once, "Why the hell do you want to take
pictures of grasshoppers?" My answers—"Because they're part of the
book I'm shooting," or "Well, I find them pretty interesting up close;
I mean, look at their exoskeletons!"—can end the conversation abruptly.
Unfortunately, the self-interest of a prairie farmer and that of a nature
photographer do not always coincide; however, farmers and ranchers

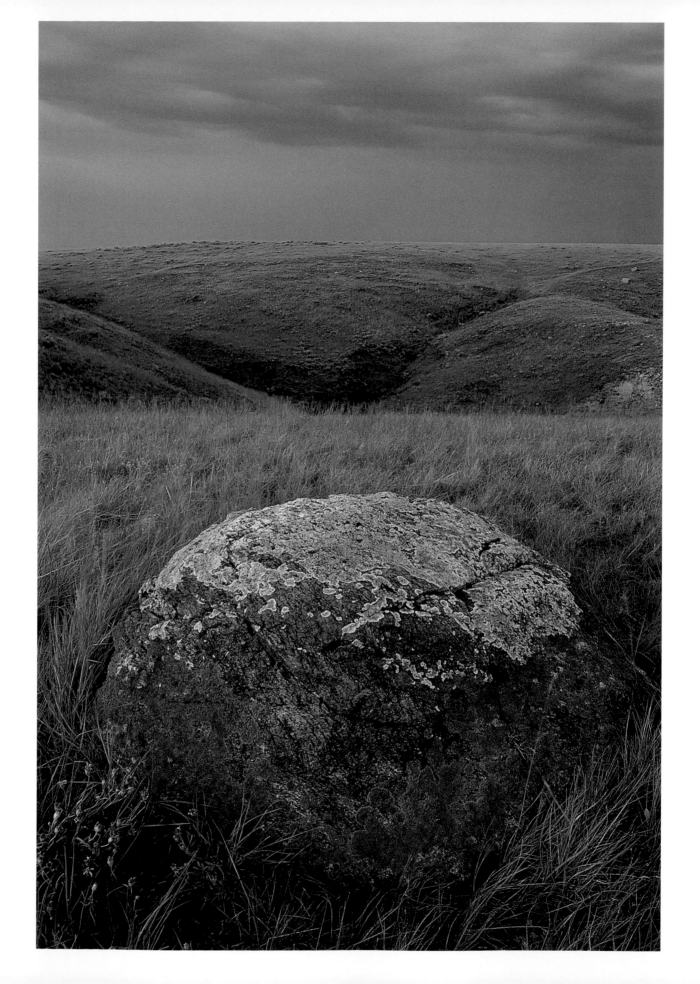

A deer mouse hides
at the edge of a wheat field.

. . .

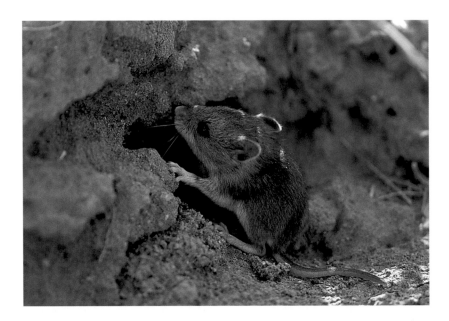

Summer

across the prairies have generally been helpful and gracious in the light of my occasionally odd behavior. If they have had judgments, they also have showed wisdom in keeping silent.

Sometimes it's enough to observe animal behavior at a distance. If summer is inextricably married to fire, it is also a season of play. One evening south of Pincher Creek, Alberta, I watched mule deer and coyotes maneuver through three or four cultivated fields at the edge of Waterton Lakes National Park. They were well out of telephoto range. A fellow in a John Deere hat watched with me; we were at a roadside scenic viewpoint. Three coyotes on a hillside, one sitting, two lying down. Four deer enter the adjacent field, single file, wary, upwind. The coyotes react instantly, all three sitting now, and a moment later separate to encircle the field, out of sight of the deer.

The deer catch a scent and immediately trot to the far end of the field, where a line of ragged hedge growth and low trees offers cover. Three of them disappear into this greenery, while the remaining deer, a doe, skirts along its border, ears up, hesitating, alert. She enters a different thicket. Now a coyote is prowling the perimeter of this thicket, nosing in, obviously aware of the deer. Suddenly the doe bursts from the thicket, head lowered, hooves flashing, and the coyote scurries away, circles at a safer distance. The doe starts uphill, toward us, leaping a series of fences with consummate grace and ease, the coyote following halfheartedly, tongue lolling. The fellow in the hat, a John Deere salesman, it turns out, laughs. "It's just a game of deer-and-coyote," he tells me, pronouncing it *ki-yute,* in true Western style. "In a

couple more months they'll be taking it way more seriously." Yes. In a couple more months the stakes will be survival.

By the end of August, most wildflowers and grasses have seeded on the northern prairie; this trend gradually moves southward. As summer winds down and the days grow perceptibly cooler, the overall level of activity among mammals and birds increases. Beavers work longer hours and are more frequently seen during daylight. Soon will come the great bird migrations. Insects, meanwhile, begin to phase out as their life cycles draw to a close. One day the mosquitoes have abruptly disappeared. Grasshoppers will hold on until the first frosts. Deer antlers lose their velvet now, becoming shiny and hard in preparation for the fall rut; prairie dogs and ground squirrels are fat from caloric intake, ready to survive the long winter in their dens. Summer, nearing its end, is like a held breath. The gathered energy, in its many forms—fat on a prairie dog, crowded seeds on the heads of wild sunflowers—will soon be needed. Not now, but very soon. When summer is finally extinguished, the fire gone like a wisp of cloud over the prairie horizon, a new game will begin in earnest.

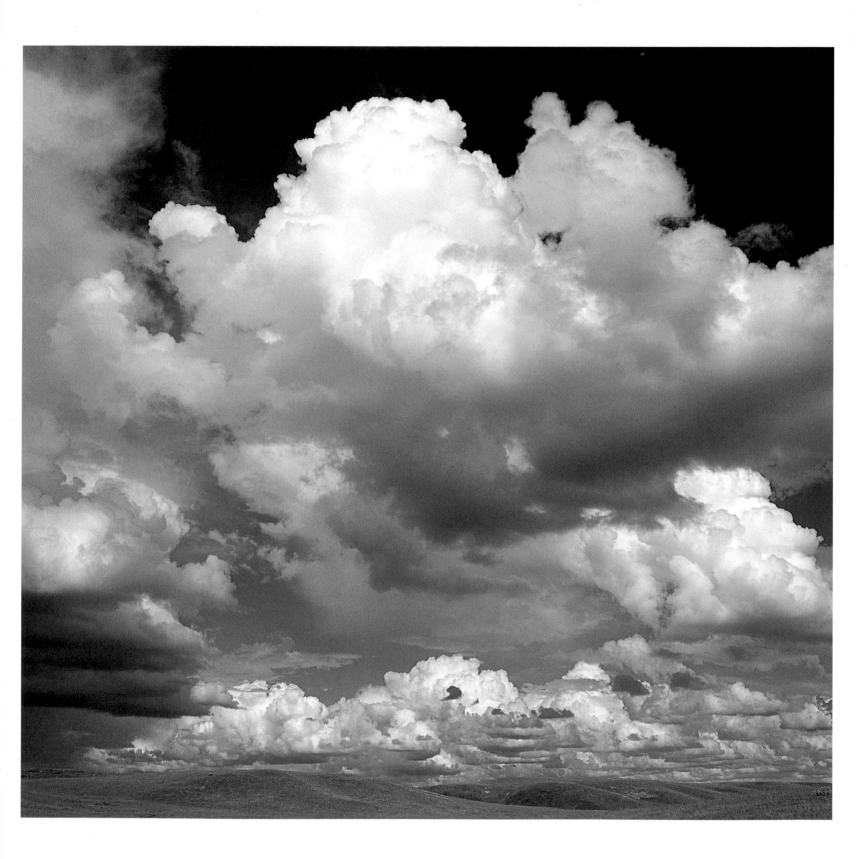

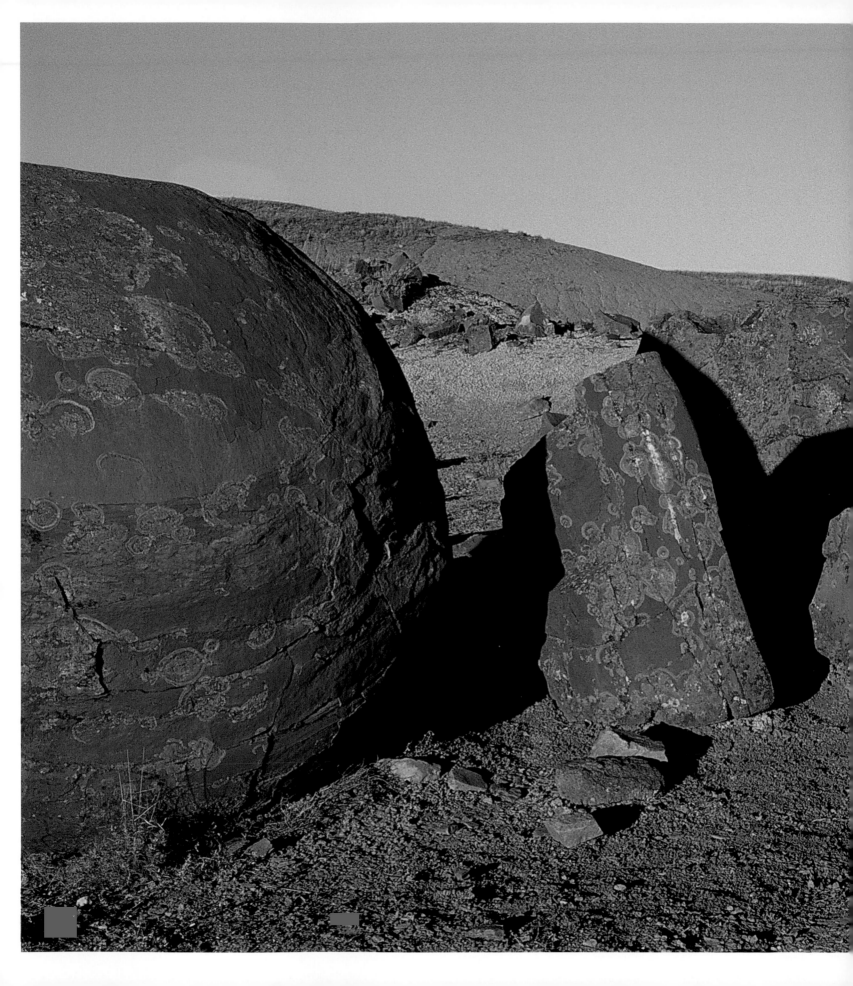

AUTUMN

COMING *to* EARTH

THE METALLIC, rasping sound came from everywhere at once, eerie and alien; my eyes scanned the yellow-brown grasses for some hint of this unexpected insect invasion. Nothing. The wind rustled dry stalks for a moment, then died down. There it was again, somehow simultaneously near and distant, a grating cadence with odd reverberations, almost hollow in tone, sounding like many voices intermingled.

By chance, I looked up. There, in the clearest blue sky imaginable, asymmetrical V-shaped lines of sandhill cranes moved purposefully on powerful wing beats. Big birds looking tiny, flying high above the prairie land, heading south, their avian voices speaking of a single necessity, their drive unfathomable to a mere human being whose life is customarily padded and protected by comforting technology. I stood, rapt, and

. . .

Lichen covers shattered concretions
at Red Rock Coulee Natural Area, Alberta.

[61]

*Sandhill cranes migrate southward in autumn
from their breeding grounds in central
Canada to overwinter in Texas or New Mexico.*

. . .

watched them go. Late September, southern Manitoba. I heard them that evening, at dusk, and again at dawn, on the fringe of Manitoba's Tall-Grass Prairie Preserve, between the little communities of Tolstoi and Gardenton. Sometime later, Robert Ducan, then-mayor of Val Marie, Saskatchewan, told me of standing with his wife, Mette, on the front steps of their renovated Convent Country Inn and watching in awe as wave after wave of cranes passed directly overhead—two hours of crane flybys to announce summer's end. Launched by the turning of the season, the cranes must abandon their breeding grounds in northern marshes to follow ancient, invisible paths through prairie skies to Texas or New Mexico. There they will come to earth once more, to rest and feed and wait out the winter months.

Autumn arrives quickly on the northern prairie; blink and you'll miss it. Some claim there are only two prairie seasons, summer and winter, and there may be truth in this perception—certainly spring and fall are mere transitions between the two dominant seasons. Yet much happens in this eye-blink season. Sudden temperature changes are characteristic; in a week the mercury can hit the chute, as meteorologists say, dropping from 95°F to a chilly 50°F. A few weeks later, overnight ice will form at the edges of prairie potholes. The incessant wind now carries a foreboding chill. Only a few bird species are able to withstand the rigors of the coming winter: ravens, magpies, golden eagles, sage and sharp-tailed grouse. Songbirds are the first to go, followed by sandpipers, hawks, and waterfowl. Great unrest on the staging grounds of ducks and geese, then great movement. There is peril from gunshot

Autumn

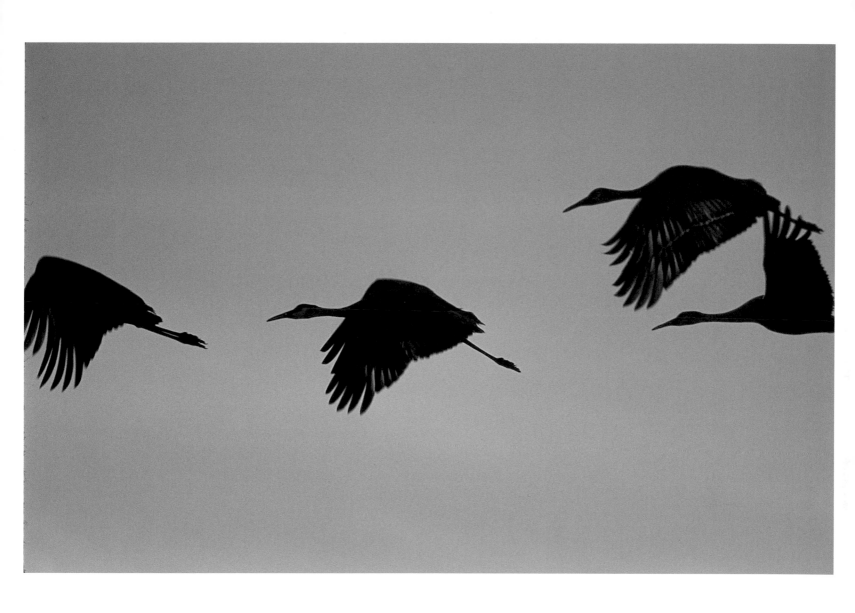

and skyscraper, the former thinning out the waterfowl ranks, the latter taking a huge toll on songbirds whose migratory routes pass through urban centers. Stress, too, is a factor determining survival in this critical period. A bird making such a commonplace yet astounding journey must be healthy and strong and have access to food and respite along the way. Deprived of these needed resources through, say, loss of habitat, birds will not return north in the spring to breed.

If you are to understand prairie autumn, especially if you have never experienced one, you must let go of preconceived ideas. There is little here to remind you of the vibrant fall colors of New England or Quebec in October, when maple and beech forests blaze with yellow and red. The prairie is more subtle, tinged instead with earth tones. Grasses fade to brown. Rosehips cling like rubies to their spiny branches. Lichen-encrusted rocks stand out, yellow-green or orange, against the prairie earth. Cottonwood, balsam poplar, aspen, and willow—where they grow—briefly turn yellow before dropping their leaves. In a few choice locations, hardwood stands put on a show. In November oak trees shed rusty leaves in the Osage Hills, at the edge of Oklahoma's tall-grass prairie. At Lost Maples State Natural Area, Texas, also in November, bigtooth or canyon maples (*Acer grandidentatum*) blaze with orange and red for a week or two. This flamboyance is the exception, however; across the prairies there is mainly a shift to the monochromatic.

If summer is fire, then fall is earth. Everything comes down to a rudimentary, bare-bones kind of truth—that the prairie is a hard place, stark, similar in many ways to desert or northern barrens. Having spent

Badlands glimmer in golden
morning light along the Milk River
in southern Alberta.

. . .

time in the Yukon, I have repeatedly been struck by the extent to which prairie resembles Arctic tundra; it reverberates in me like an enduring chime. I am drawn to open country, to places where the earth reveals its contours in elemental form. The land laid bare, its geologic gyrations evident in prairie hills, buttes, coulees, and arroyos—this was what I hoped to translate into visual terms as I crisscrossed the prairie in three successive autumn seasons, searching for images.

One autumn, driving south to Kansas and Oklahoma to capture the tall-grass prairie on film, I stopped at DeSoto National Wildlife Refuge. Straddling a channel of the Missouri River on the Iowa-Nebraska boundary, this refuge is vital habitat for up to 800,000 migrating snow geese, whose numbers peak in late November and early December. All reports indicate a phenomenal wildlife spectacle.

The refuge is superbly laid out. I could imagine its frost-coated grasses under crisp blue skies and clouds of white geese rising heavenward with a great collective vocal outcry. Alas—no such luck. The really intense activity does not occur until a cold snap, and luck abandoned me during my visit. The hoarfrost that had greeted me in Montana gradually melted away, the skies loomed leaden and melancholy, rain drizzled down. Refuge staff had no idea where the snow geese were; "Elsewhere," they told me.

I walked several trails off the main loop road, noticing that my emotional landscape reflected the weather. What could I do with such dull, overcast light? Finally I pulled out my old macro lens, one I have had so long that it feels like an appendage. Using it allows me to slip into a

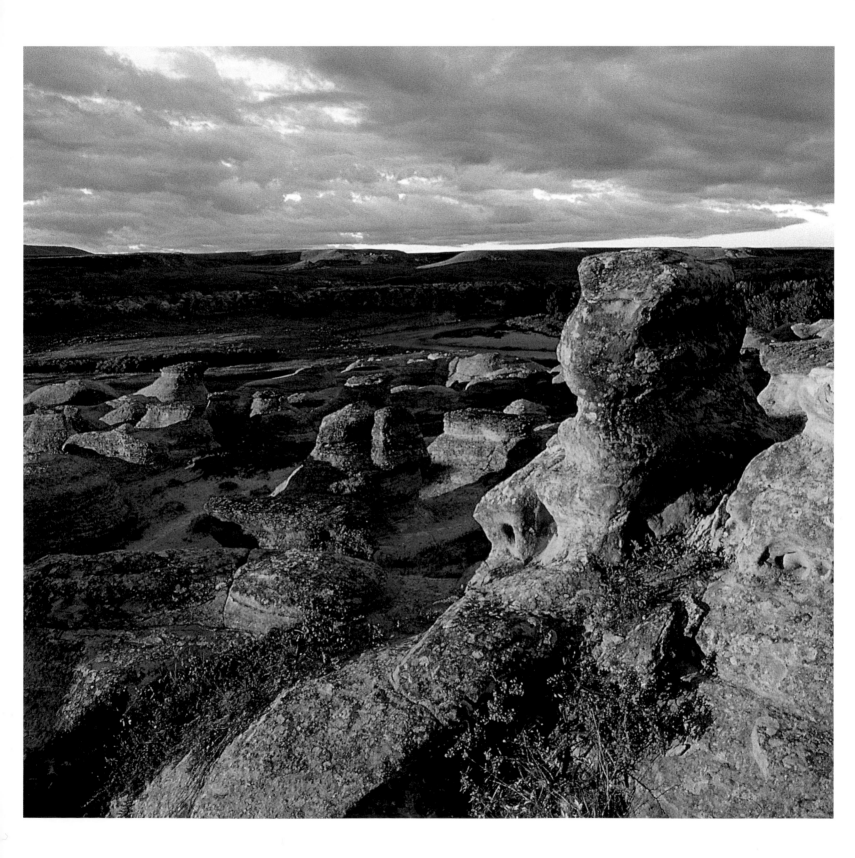

Autumn

By late November, bigtooth maples have
dropped most of their leaves at Lost Maples State
Natural Area, north of San Antonio, Texas.

. . .

comfort zone where technique becomes automatic and I can work with various compositions quickly and intuitively. I spent the next few hours making closeups, gradually becoming excited at the saturated colors that jumped into my viewfinder as I focused my lens on details: rich green mosses and lichens on a fallen tree trunk, dark lines tracing pale bracket fungi on a stump, a pattern of brown aspen leaves on the forest floor. By the end of the day I felt elated, because I knew that every pleasing image from this shoot had been salvaged from potential defeat.

A few days later, sunshine returned. I found snow geese farther south and had plenty of opportunities to make big autumn landscape shots in Oklahoma and Texas. But, oddly, my meanderings in Iowa rain were among the most satisfying of that trip.

Just as prairie skies were a frequent subject for my lens during the stormy summers, the land itself seemed to open for me in autumn—a different sort of coming to earth. On one late September jaunt through southern Alberta, I wandered among the bizarre landforms of Writing-On-Stone Provincial Park. Here the Milk River has cut a canyon through layered sandstone from which subsequent water and wind erosion has sculpted fantastically shaped hoodoos—pillars of stone. The Blackfoot and other indigenous peoples considered this valley sacred and marked the cliffs with petroglyphs that give the present-day park its name. I believe they were on to something; the place resonates with an intrinsic power. It is an enticing location for any landscape photographer.

Great images depend on great light. Photography is all about light— waiting for it, recognizing it, and when the good light does come, knowing

what to do with it, fast. The first evening a huge cloud bank obliterated the sun just as it was sinking low enough to deliver the warm-tones landscape photographers love. But I could see a gap between clouds and horizon line where the sun seemed likely to appear. I sought a viewpoint over the valley, river, and hoodoos, with the Sweetgrass Hills of Montana in the background, and eventually found a pleasing composition. The wait for the sun's appearance was agonizingly slow, as the area of open sky constantly threatened to close up. When the sun emerged and the landscape flooded with gold, I made the shot—with many variations—and then cast about for something else to photograph.

Gusts of evening wind were whipping the golden grasses at the base of some small cottonwood trees. I ran toward them, hoping the light would last, and quickly set up my tripod. Over the next few minutes, I made several dozen photos, shooting into the light with a slow shutter that deliberately blurred the grass into abstraction; I was now working instinctively. Total immersion. When I finally pulled my eye back from the viewfinder, I was astonished to find myself still on that hill above the Milk River. Now the sinking sun began to turn the sandstone blood red. At the same time, a full yellow moon slipped over the far canyon rim and surged into the eastern sky. A chorus of coyote voices filtered through the sounds of gusting wind and rattling leaves, and three mule deer appeared from nowhere and tentatively crossed the open hillside in front of me as I shot the red rock landscape in the last, lingering light. A classic ending to a fall evening on the prairie: vital, energizing, unforgettable.

Autumn

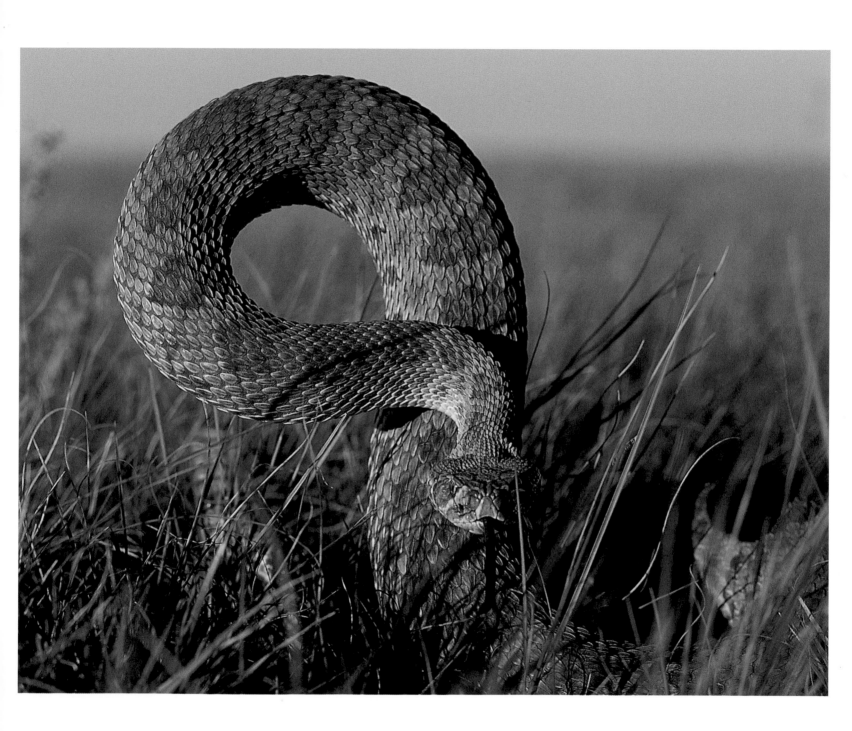

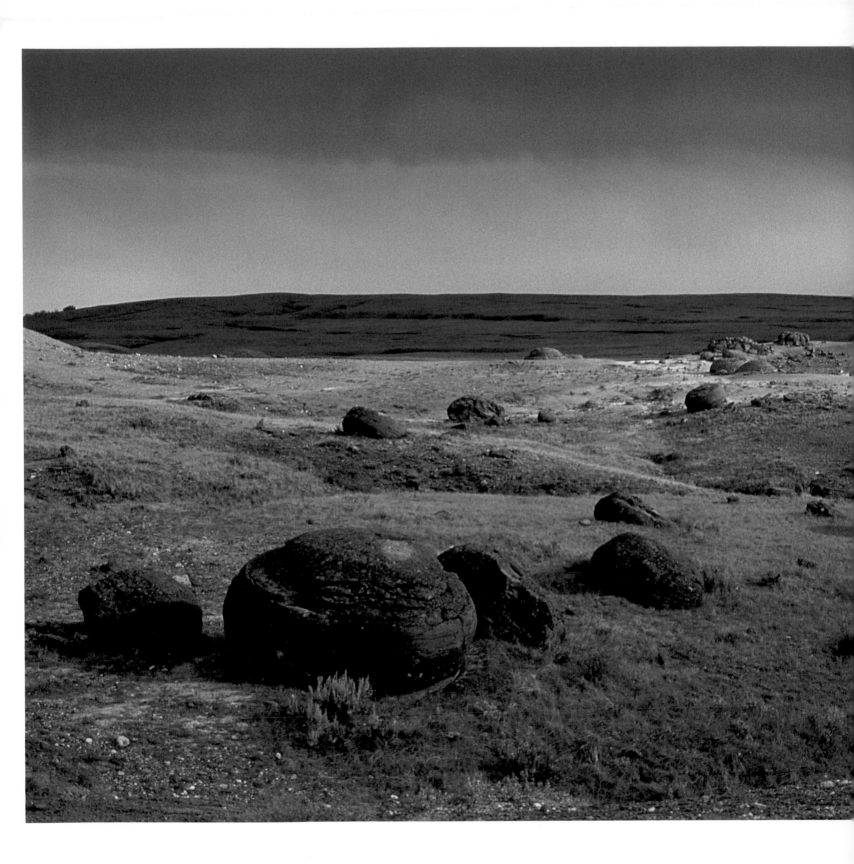

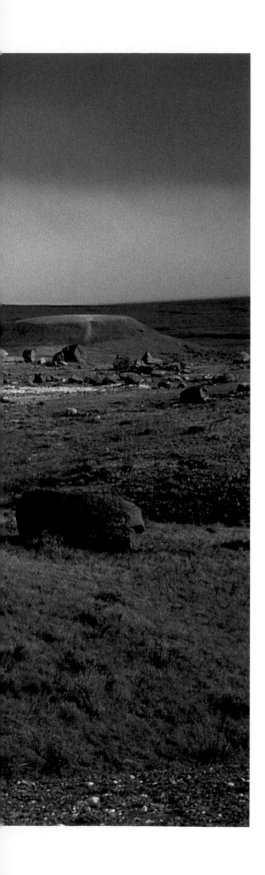

LEFT: *Red Rock Coulee, Alberta, dries out after a rainstorm.* ABOVE: *A quartz vein weaves through sandstone layers at Caprock Canyons State Park, Texas.*

· · ·

Autumn

LEFT: *Bracket fungus, DeSoto National Wildlife Refuge, Iowa.*
BELOW: *Sandstone hoodoos wear an ironstone cap, Dinosaur Provincial Park, Alberta.*

· · ·

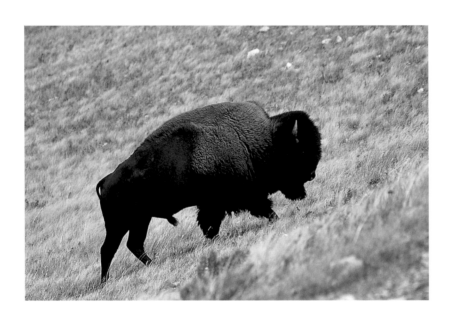

ABOVE: *A bull bison grazes on the*
short-grass prairie. RIGHT: *Grasses swirl in the wind,*
Writing-On-Stone Provincial Park, Alberta.

· · ·

Autumn

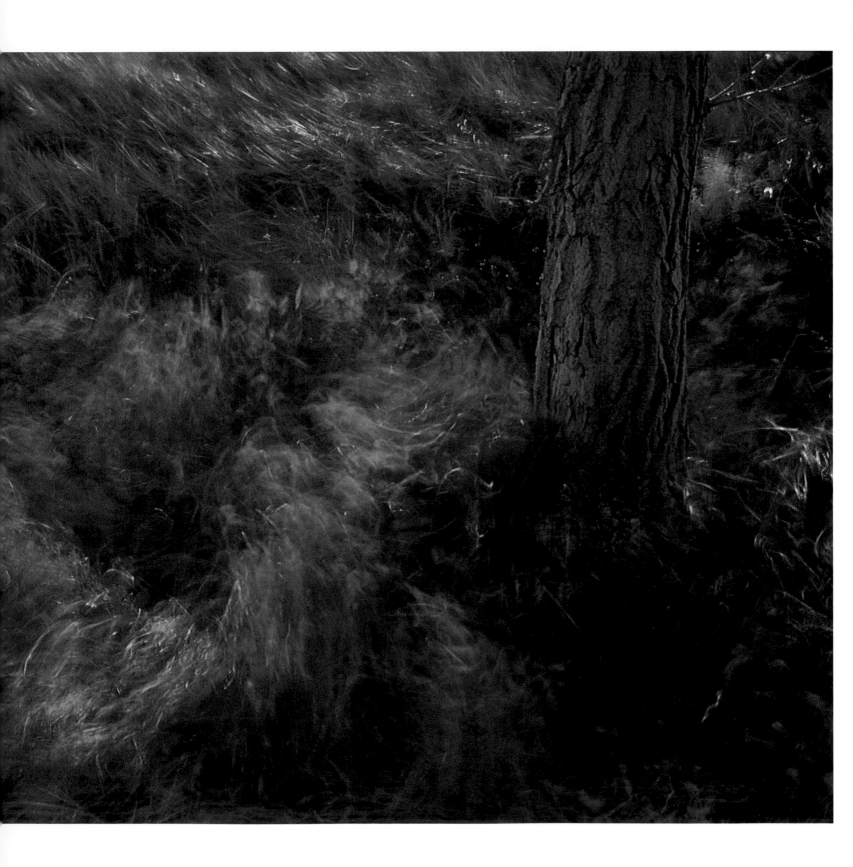

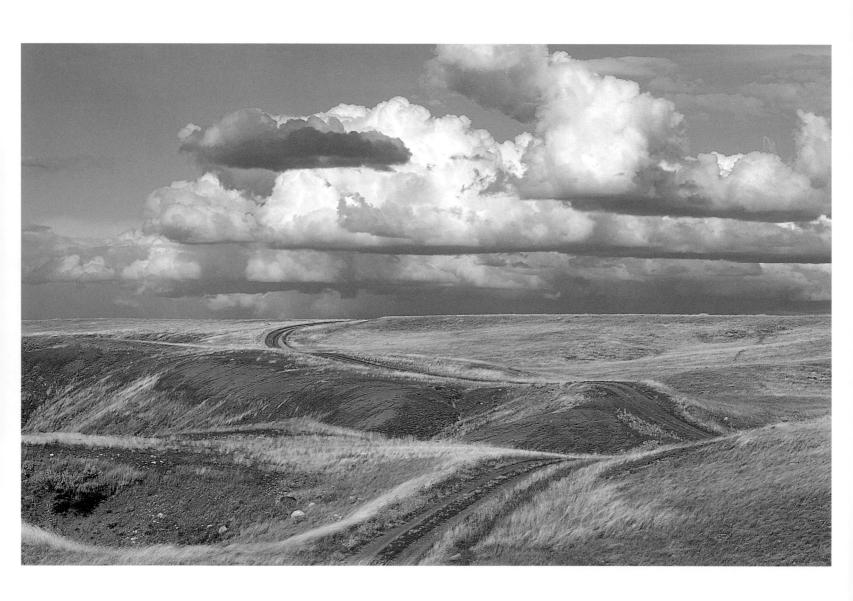

Autumn

Clouds sail over high lonesome
prairie in September, Grasslands National
Park, Saskatchewan.

. . .

Farther west, in the rolling rangelands of shortgrass prairie, lies Waterton-Glacier International Peace Park, the joint name given to Glacier National Park in Montana and Waterton Lakes National Park in Alberta. Both parks are mainly known for their mountain terrain and wildlife, but in addition to straddling an international border, they sit at the meeting place of mountains and prairie, and their eastern flanks are graced by the wildflowers and grasses of both. Thus, we find prairie plants such as gaillardia, smooth blue beard tongue, and prairie smoke climbing the mountain slopes along with Indian paintbrush, glacier lily, and arnica.

In September you can hear the elk bugling. Elk habitat in the twenty-first century is almost exclusively montane, but herds once ranged across the entire prairie west of the Missouri River. At Waterton they are commonly seen on stretches of upland prairie east of the foothills and among alternating prairie and aspen park land in the valley bottoms. Most grazing mammals go into the annual rut in the fall—bison, which mate in July, are the exception. Autumn, a time when biological imperative drives ungulates more fully than the need to eat or rest, takes an enormous toll on those animals mature enough to compete for the right to mate. A bull elk protecting its harem, and mating as often as possible with as many cows as possible, might deplete its resources by going weeks without food and thus have no chance to survive winter. Death is a commonplace occurrence, a literal and final coming to earth.

Prairie dogs and ground squirrels come to earth in a different way. Although their fur coats and subcutaneous fat layers provide insulating

*Gnarled limber pines hug the grassy slopes
of Whaleback Ridge in the Rocky
Mountain foothills of southwestern Alberta.*

. . .

warmth, there simply is not enough forage to sustain activity through winter, so they retreat to their underground dens and enter periods of deep torpor or hibernation to conserve the vital energy needed for survival. Intense feeding takes place in the final weeks of autumn and may continue even after the first snowfall. One October morning in a prairie dog town in Grasslands National Park—home of Canada's last remaining "dog towns"—I spent a morning photographing the diminutive residents. There was new snow on the ground, and a cutting wind numbed my fingers as I hunched down low, in the open, surrounded by scores of black-tailed prairie dogs; one deer mouse, which raced across an open space directly toward me and dived down a prairie dog burrow; and one Richardson's ground squirrel (*Spermophilus richardsonii*). The last, commonly referred to as a gopher, was close by, rummaging among dried stalks of grasses and forbs poking out of the snow and regularly retrieving morsels that at first I took to be succulent roots. A closer look, however, identified them as frozen grasshoppers. Until that moment, I had not known that these prairie rodents would feed on insects. But why not? They are a readily available source of high-quality protein, and apparently the gophers' digestive systems can manage them. Soon it would be snug in its underground den, waiting out the long freeze-up, dreaming, perhaps, of the first green shoots of spring.

Autumn now speeds to a close. Early snows swirl, filling small-town streets with drifts, leaving behind a land somehow blunted, colder, numb with the first touch of winter. A strange silence descends. No more birdsong, sawing of katydids, barking of prairie dogs. The earth

Autumn

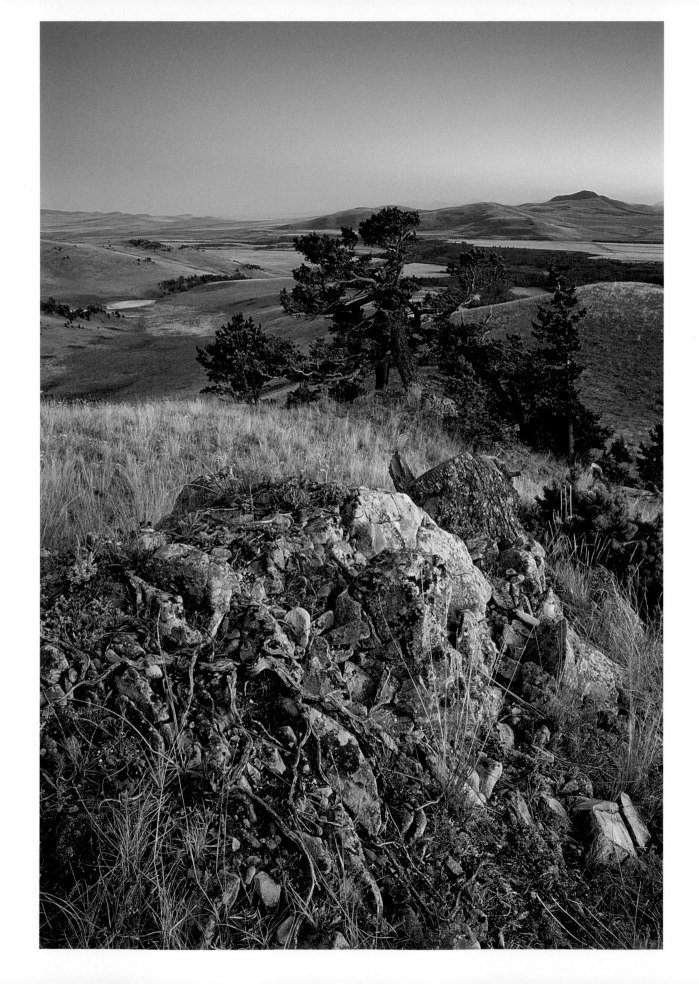

itself seems somehow amorphous, as if waiting for an unseen signal to begin the next stage of transformation. Pronghorn that have spent the warm months roaming the prairie in twos and threes now band together in herds of a hundred animals or more; their insulating coats will allow them to withstand the worst cold and wind chill winter can offer. Ecto-thermic, or cold-blooded, rattlesnakes and their kin have gone to den, where they will wait out the winter wrapped in mutual warmth. Scat-tered bare trees, branches of thickets—all have been stripped down, denuded, revealing abandoned bird nests rimmed with morning frost.

It has come to this, the bones of the earth, a reduction to the sim-plest forms. The grasses—their autumn seeds long since shed, brittle skeletons masking the deeper resilience of roots still alive beneath the cold ground—stand like relics of summer, and the wind blows hard.

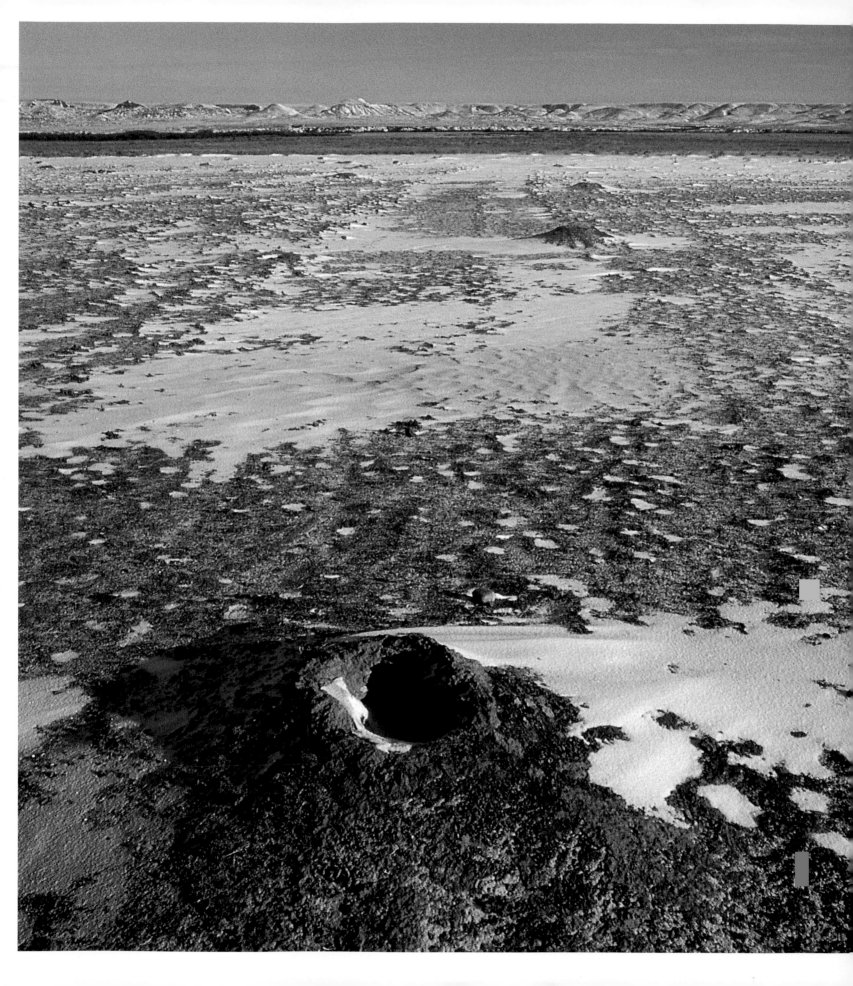

WINTER

a QUESTION of SURVIVAL

WHEN ROBERT AND METTE DUCAN of Val Marie, Saskatchewan, invited me to spend a winter as artist in residence at their beautiful Convent Country Inn, I recognized it as a unique opportunity. I had never experienced winter on the Canadian prairie. The mere mention of it felt loaded with psychological implications; if the infinity of sky and space that characterizes the summer prairie is daunting to contemplate, what, then, of winter? Take away the green mantle, the birdsong, the thousand voices of insect and animal life, and what is left? An overwhelming emptiness. A lone, windswept, frozen land.

One must recognize from the outset that nature is not scenery; it is not a view, something apart from ourselves. This is true in all circumstances, in all seasons, but especially so when the game turns deadly

. . .

A prairie dog town lies frozen in December,
Grasslands National Park, Saskatchewan.

Leaves are trapped in the
melting ice and slush of late winter.

. . .

and the stakes are high. To travel through the prairie in winter, one must learn the rules, different from those that apply elsewhere, and measure success by the ability to make the critical choices that ensure survival.

Winter, rattling its bones from Arctic Canada down long windways, across the lone prairie, is a fearsome entity. My earliest encounter with this ferocity came on a bitingly frigid day that began in a motel room in Dickinson, North Dakota. I was on the final leg of a long mid-December drive from Ann Arbor, Michigan, to Val Marie. I had mucked my little car through a heavy snowfall near Chicago and entered a zone of deep cold at Fargo, North Dakota. In Dickinson, the TV weather channel predicted a windchill factor of -70°F, calling conditions "deadly" and advising against travel. But I was a day away from my destination, and so I took the chance.

In the Little Missouri National Grassland, after a surreal early morning drive through a world of drifting snow that obscured road surfaces and at times mesmerized me with its snakelike, twisting patterns, I noticed a perfect ring around the low winter sun. A sundog. I pulled the car over, left it running, and trotted back along the roadside with my camera to find a good angle of view. Nearly all my photography is done from a tripod, but this was no time to fumble with cumbersome gear; I hand-held the camera and worked fast. A quick calculation of exposure, four or five shots; then I raced back to the car and tumbled inside, fingers numb to the bone and soon burning with renewed circulation. Breath coming in hard gasps. Glasses iced over. Beard frozen.

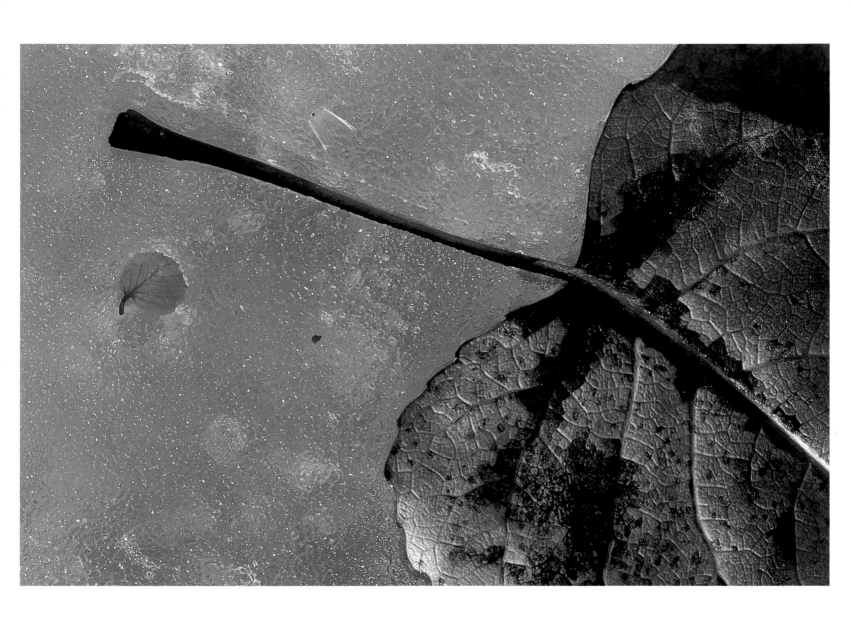

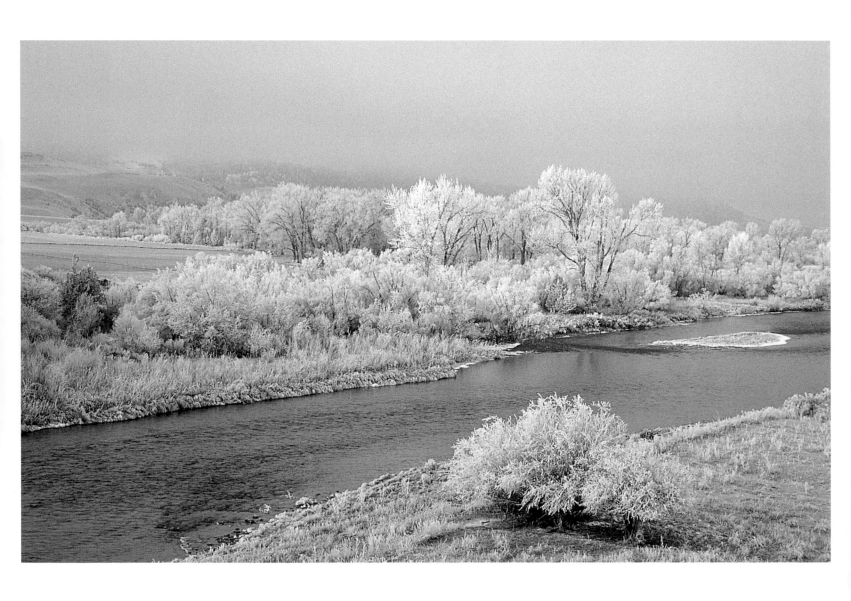

Winter

November hoarfrost cloaks
trees along Clark Fork River near
Drummond, Montana.

. . .

Even for someone long familiar with winter, dressed for it and cognizant of its bite, the cold was unbelievable.

Survival, the first imperative during winter. All animals have their specific adaptations, and here is mine: a list of my typical garb for an outdoor shoot on the prairie in winter. Photographers might hike to a location, but much of their time is spent standing still, waiting for something to happen (or squatting, sitting, and even lying down on the job), so the insulation has to be exceptional. In general, a layer system works best:

long insulating underwear (top and bottom)
light fleece shirt
heavy wool sweater
fleece pants
wool socks
insulated boots
down parka with hood
wool scarf
wool hat
cotton liner gloves
wool mitts
wind pants (for windy days—that is, most days)

Heavily layered yet still mobile, I can manage a couple of hours in -35 temperatures. The liner gloves allow me to pull mitts off and still handle camera controls; even so, the cold has a way of seeping in, and

*Bare trees cast shadows on
the sand in December, Monahans
Sandhills State Park, Texas.*

. . .

batteries run out of juice quickly. More than once I have cut a session short because changing batteries in such intense cold was simply too exhausting, both physically and psychologically. I would return home feeling battered.

The deep cold of northern prairie winters has led to many adaptations among wildlife. The feathered legs and feet of sharp-tailed and sage grouse, for example, provide some insulation from the frozen ground. Birds without feathered legs have made circulatory adaptations. Ravens in the north have thicker horny pads on their feet than southern ravens. Bison use their great shaggy heads to brush away snow and expose edible vegetation; in addition, their massive size and thickly layered coats trap and retain heat. Coyotes are active throughout the winter, hunting many prey species, including mice and voles, grouse, rabbits, and deer; I have seen one in January with its nose and half its body down a prairie dog mound, tail pointed skyward. But this stance was merely wishful thinking, as the earth was frozen solid and the resident lay sleeping far underground.

Danger from predation is probably the main reason deer and pronghorn form herds in winter. Not only are depleted animals less able to flee when necessary, but as they focus on finding something to eat they might also be less alert to a stalking predator. By gathering in large groups, deer and pronghorn can use the herd's collective eyes to spot danger in time to escape. Nevertheless, as winter progresses through increasingly lean months, old, sick, and injured animals become correspondingly more vulnerable to predation. When the snow finally melts

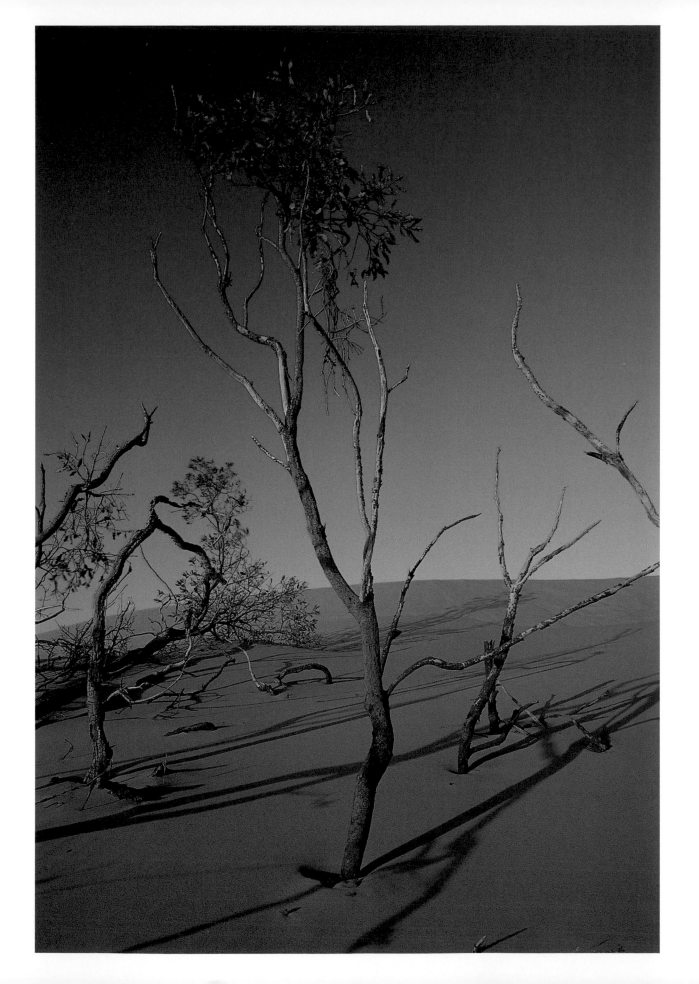

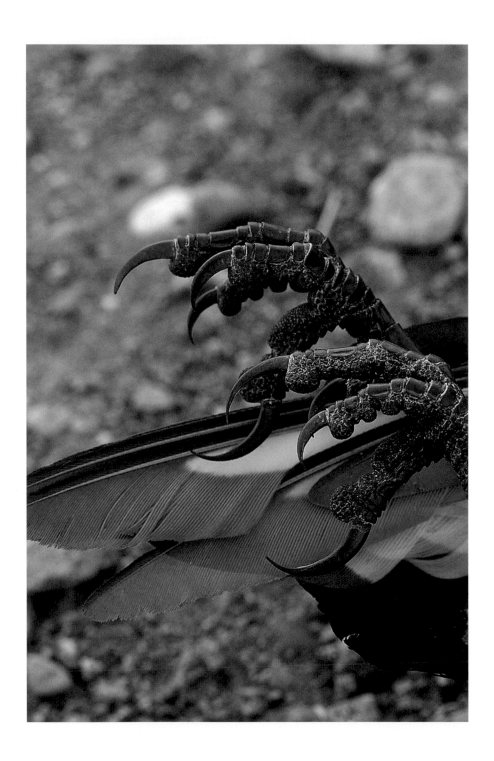

away in spring, the remains of winter kills will be revealed: gnawed bones, scattered and bleaching in the sun.

Climatic harshness notwithstanding, there is an undeniably beautiful, even pristine quality to the prairie winter. The pink light of sunrise and sunset on clean snow can transform the landscape into something almost edible: a tantalizing dessert for the eyes. Because of the lack of atmospheric moisture, relatively little snow falls across the central Great Plains and grasses can usually be seen poking through the thin drifts; likewise, rocks are seldom entirely covered. Thus, the contours of prairie lands are clearly outlined. For a photographer, this is an extraordinarily graphic offering: a winter landscape of pure white and tones of clean pink and blue, with etched contour lines. Few other landscapes are as striking to photograph.

Good nature photography is about simplifying things down to essentials: nothing extraneous, yet nothing missing. If forests and mountains tend toward visual complexity, prairie landscapes have an inherent simplicity. San Francisco artist Leigh Hyams once told me, "I'm really interested in what I can say with the least. Can I suggest a waterfall with a few marks? Can I suggest a forest?" Photographing the prairie is a similar process. Can I suggest prairie with a few shapes? Can I suggest winter? Sometimes the prairie itself seems so empty as to be more suggestion than reality; often a scene can be reduced to, say, two rectangles and a cloud. Furthermore, light leaves its tracks on film in different ways from the light we see through our eyes, and the viewfinder itself operates as a sort of reducing valve by cutting out

everything beyond its borders. The result—both in the "real" world and through the lens—is a landscape of imagination and inference. And at no time is it more dreamlike, more otherworldly, than in winter.

Across the northern prairie states—Montana, the Dakotas, Minnesota—winters are similar to those in Canada. Moving southward, there is a lessening of intensity, evident in a higher number of frost-free days per annum, overall higher average and mean temperatures, reduced amount of snowfall and numbers of blizzards per winter, and so on. (South Dakota, once known as the "blizzard state," now goes by the official nickname "The Mount Rushmore State." I suppose winter is not considered a big tourist draw.)

During winters with minimal snow cover in Saskatchewan, I have driven south through the Dakotas, Nebraska, and Kansas and found, to my surprise, bare expanses of brown earth, with no snow accumulation whatsoever. Although it is possible to get nailed by a winter storm in Texas, winters in southern prairie regions generally are relatively mild. At Caprock Canyons State Park, in northern Texas, where the high plains break along an extensive, exposed, and eroded ridge of red sandstone known as the Caprock Escarpment and segue into the rolling plains to the east, I enjoyed the luxury of camping in December. I was hoping for snow, but park staff informed me it had come and gone in November; instead I had to settle for days of glorious sunshine and clear nights with light frost. The weather was too cold for reptiles to be about, but there were deer, cottontails, cardinals, and mockingbirds. Every night I heard coyotes in traveling packs, yipping and howling up and down the valley.

Winter

And what a valley—towering cliffs of sandstone that turned fiery red at sunrise, threads of quartzite embedded in sheer canyon walls, stands of weathered juniper, spiny pads of prickly pear, and dry, curling grama grass crunching underfoot on the rocky valley floor. It felt less like winter than late fall; the greatest inconvenience was shorter days and longer nights that required extra time in the sleeping bag.

At Monahans Sandhills State Park in western Texas, I encountered pleasant days of sunshine. Supporting more grass species and trees than true desert, Monahans is nevertheless very desertlike in appearance and consequently was a joy to photograph. Nights were very cold. Several days in a row I hauled myself out of the sleeping bag to leave camp before dawn and hike to a location far enough from the main park road to be free of footprints, allowing me to shoot untrammeled, pristine dunes. On clear days the rising or setting sun cast long shadows and emphasized textures; every set of ripples receiving low, slanting light became a potential composition. As I shot roll after roll, I could feel myself spinning out toward the edge. Isolated, happy, focused—and traveling alone—I encountered few distractions and could concentrate fully on making the images.

In southern Saskatchewan, winter holds on fiercely through most of March. By late February daylight hours are growing noticeably longer, and on some days the cold is less intense. It is now possible to venture outdoors for longer periods without the danger of frozen extremities.

I took one such afternoon to hike the twisting, turning, frozen-solid surface of the Frenchman River. Still covered with snow, it revealed

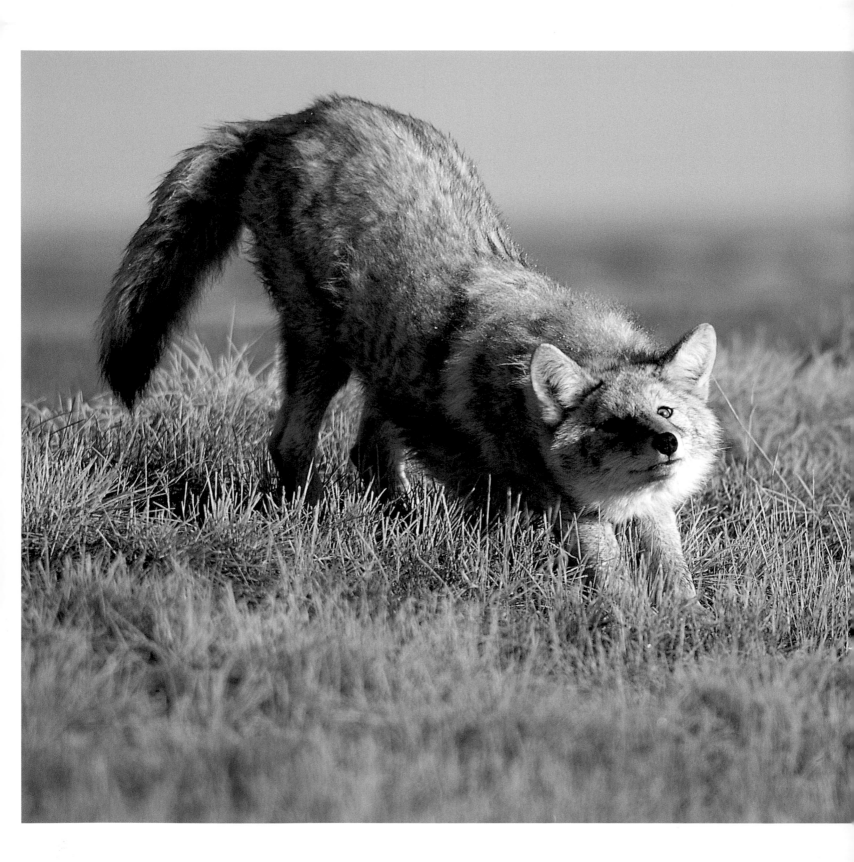

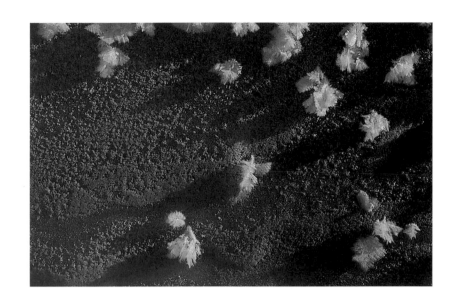

LEFT: *A coyote stretches after waking from a nap.* ABOVE: *Frost crystals fleck the surface of a frozen pond.*

· · ·

BELOW: *A water-parsnip seed head lies locked in ice.* RIGHT: *Jagged ice crystals reflect the freeze-thaw cycle in March on the northern prairie.*

· · ·

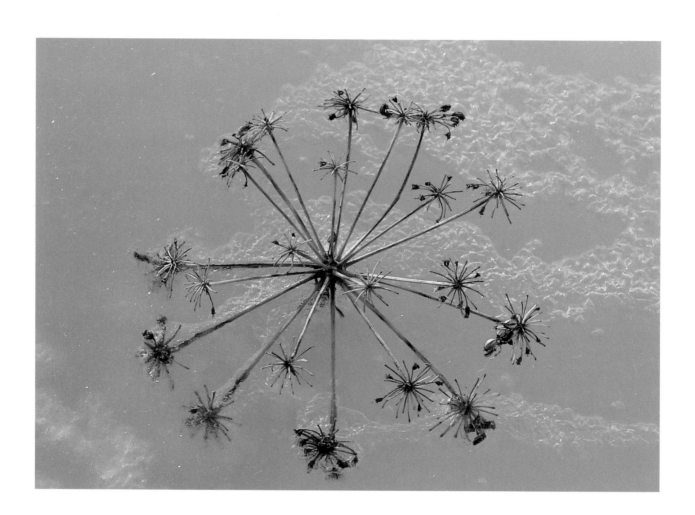

Winter

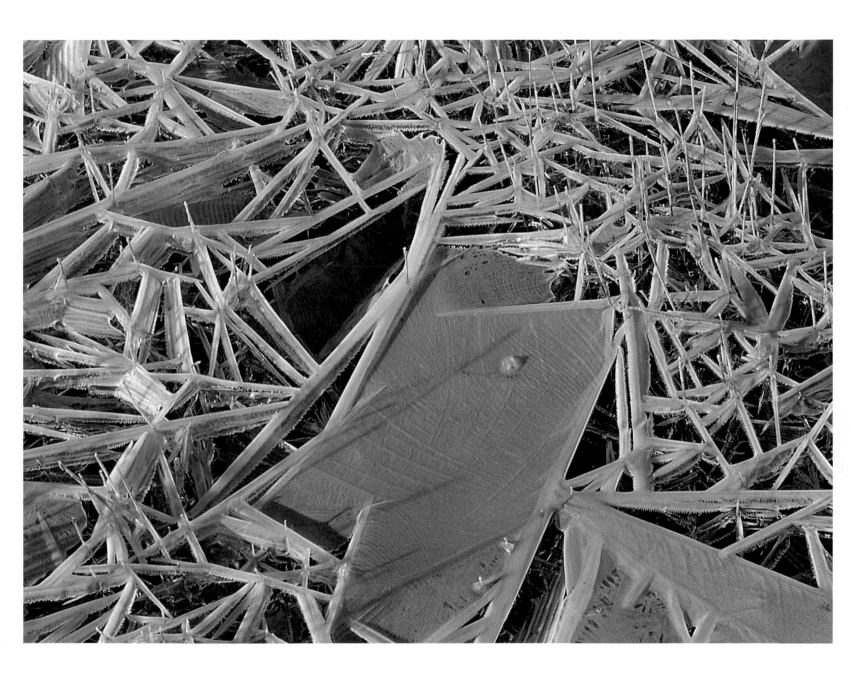

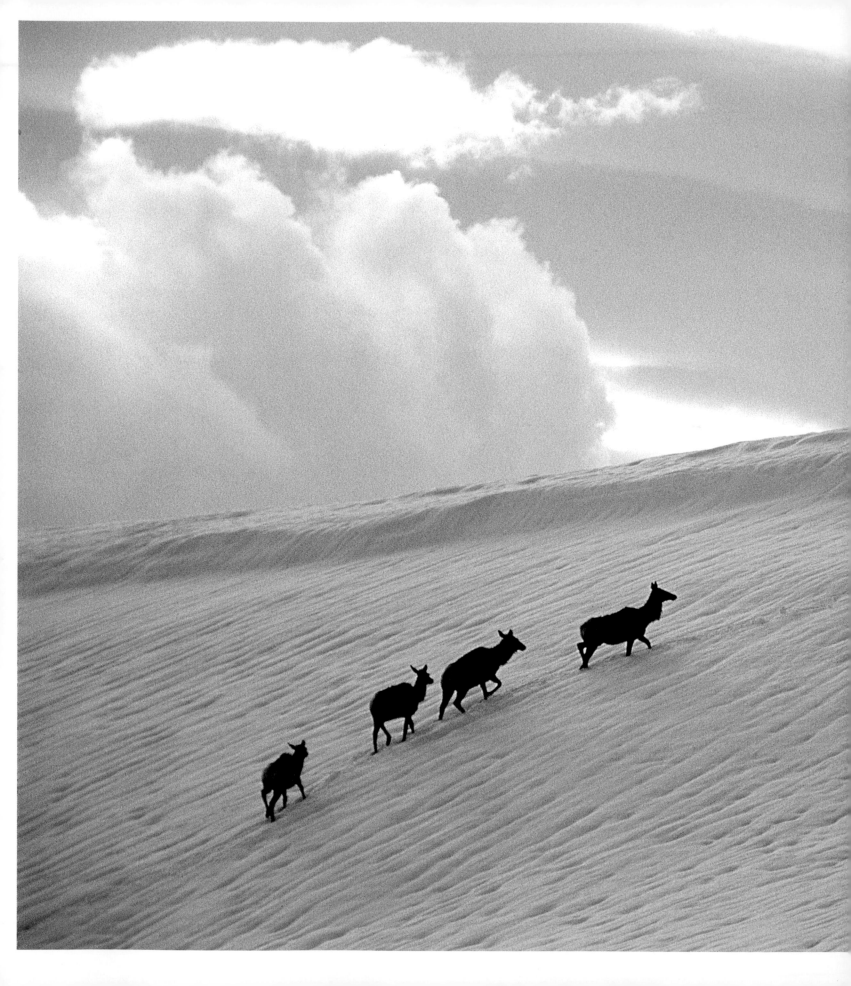

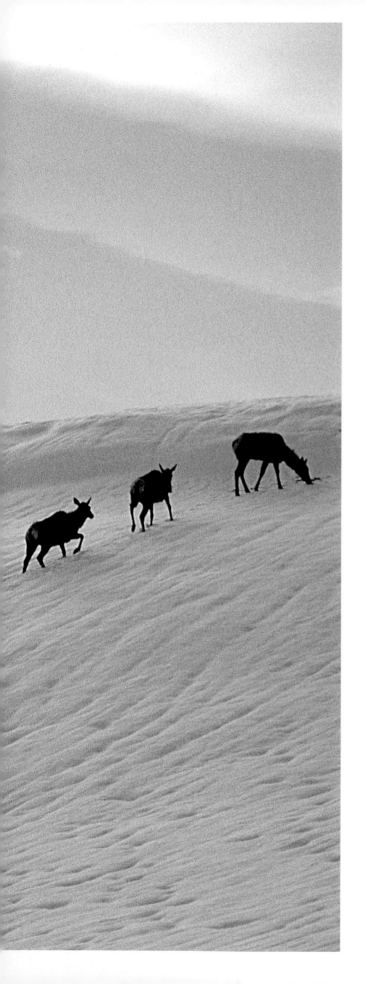

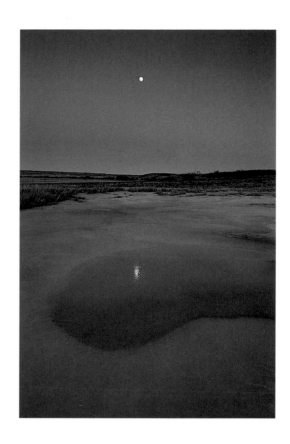

LEFT: *Elk climb a snowy ridge in the*
Rocky Mountain foothills in late winter.
ABOVE: *The moon rises over a frozen pond*
in the deep cold of December.

· · ·

*Pink snow and blue shadows of late
afternoon highlight the spectacular view from Eagle Butte
in Grasslands National Park, Saskatchewan.*

. . .

tracks of deer, pronghorn, coyote, fox, and raven, although in daylight, using no concealment and trudging along rather laboriously, I didn't see any of the track makers. Protected from the wind by low, steep clay banks, I could feel warmth from the sun on my face for the first time in months. I imagined the river moving sluggishly beneath thick ice and thought of sleeping beavers and muskrats, hibernating frogs and salamanders, absent ducks and herons—all the life that would depend on the river's murky waters only a few months hence. They had to survive the lean months to reap the reward: another chance at mating and breeding, another chance to grow fat and strong in the sweet season ahead.

The winter had been relentless except for one or two chinooks—warm winter winds—breezing down from the Rockies and whipping across the plains in January or February, briefly turning the prairie into a dripping, sodden caricature of spring, only to freeze again in the next cold snap. Now, with the approaching spring equinox, real change was in the air. March generally produces a freeze-thaw cycle. Odd ice formations develop overnight in ponds: long hollow crystals with needle-sharp points. When meltwater seeps into cracks and pores, only to expand during nighttime freezing, the resulting frost heaves form mounds in bare earth and damage road surfaces. It was during this time of turning, that held-breath moment when winter seemed willing to relax its grip for good, that I met a coyote one frosty morning in Grasslands.

Coyotes are a frequent sight across the prairies. I can't think of an animal that has proven more adaptable or successful, especially in the light of persecution by humans. Even ranchers and farmers who like

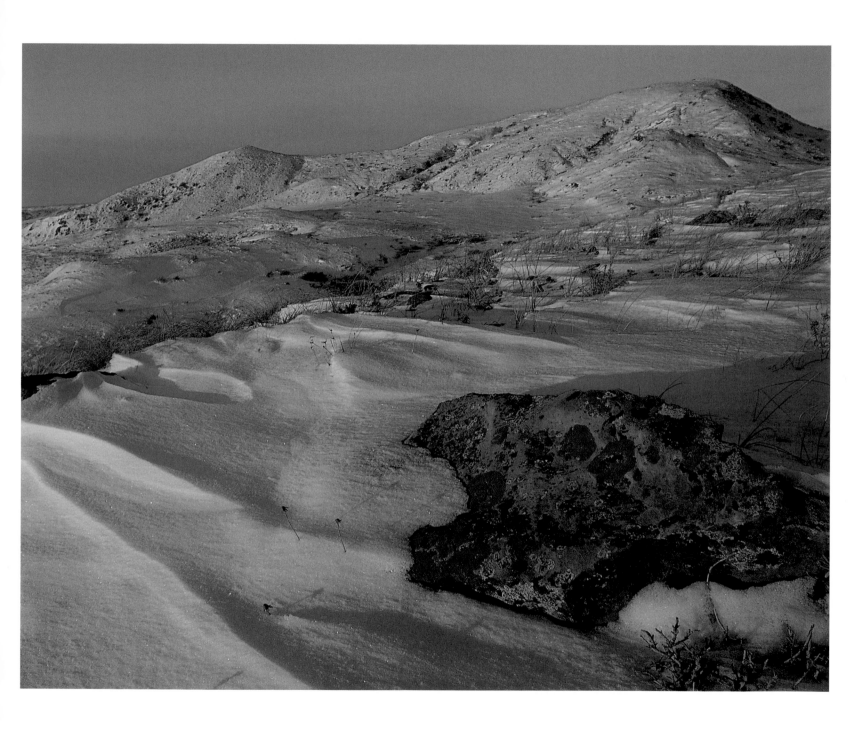

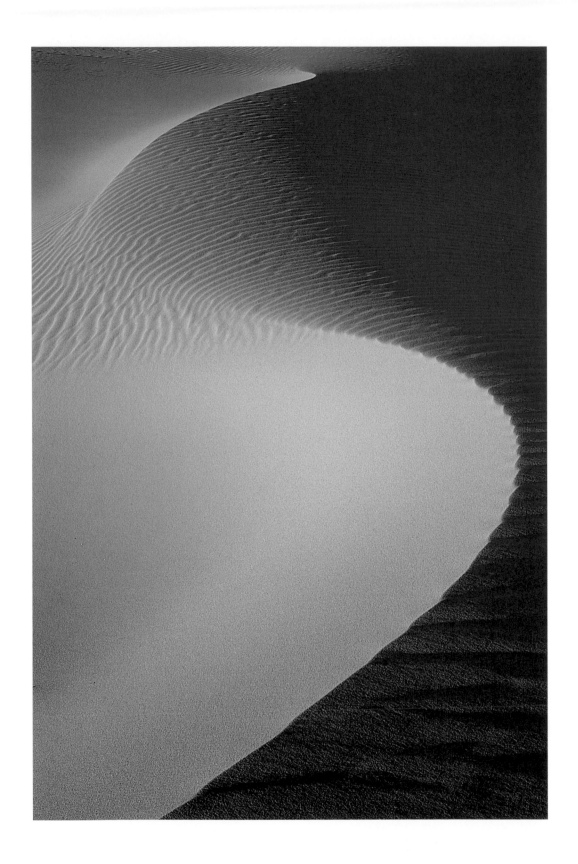

Morning light traces a graceful
curve in dunes at Monahans Sandhills
State Park, Texas.

. . .

seeing coyotes, who enjoy their night song and appreciate their presence as a sort of prairie icon, often shoot or trap or poison them. After all, they are considered the competition. Coyotes in prairie habitat, therefore, tend toward wariness. Although I wanted a decent photo encounter, I wasn't willing to set out bait or use some similar deception to draw them in. After a hundred distant sightings or close glimpses of a flashing tail and hindquarters tearing up the prairie turf, in March 2003 it finally happened—a coyote accepted my presence for an extended time and allowed close, even intimate, photos.

It was a healthy animal, alert and curious. I spent a magical forty-five minutes with her just after dawn, using my car as a makeshift blind. The coyote knew I was there. We made eye contact. She walked up and sniffed my rear tires. The encounter reached its climax—for me—when she chose to ignore me and curled up in the frosty grass for a short nap. I felt honored by this matter-of-fact acceptance.

Although I was concerned that my human profile would frighten her away, I couldn't resist the temptation to get closer to her. I slowly creaked the car door open, slipped out, tiptoed across the road, found my own patch of frosty grass, and settled myself down. Through all of this activity, her ears flicked, tracking me, but she did not raise her head or blink an eye. I waited. Waited some more. Finally, she rose to her feet (click!), stretched (click!), trotted over to assess me at close range (click!), yawned (click!), and at last took her leave.

The smile stayed plastered to my face all day. I had been given a rare glimpse into a coyote's world, a reward for all the early risings in a

cold house and coffee gulped in darkness with one hand on the wheel, out in the middle of nowhere, headlights cutting a thin shaft through the dim predawn light.

As the final weeks of winter wind down, there is a sense of combined relaxation and anticipation, and the air seems to carry new scents for the first time in many months. Wetland areas around lakes or marshes reveal a multitude of animal tracks, impressed into slush one evening, frozen into icy records of travel the following morning. Gone are the nights of really deep cold, however, and subzero mornings of ice fog or hoarfrost. Sharp-tailed grouse begin congregating on their leks, the staging grounds for their elaborate courtship rituals, and sage grouse won't be far behind. Western meadowlarks arrive in great numbers. Prairie dogs and ground squirrels become active again. Buds swell on branches of wolf willow and trembling aspen. Spring is at hand.

There is no fixed timetable, of course. Blizzards can come roaring in from the northwest any time. But the power of winter has diminished, yielding to longer daylight hours as the sun traces an ever-higher path through the sky. The headlong tumble into spring is beginning. The living prairie is about to reawaken.

Blowing snow writhes across the
highway near Grassy Butte, North Dakota.

. . .

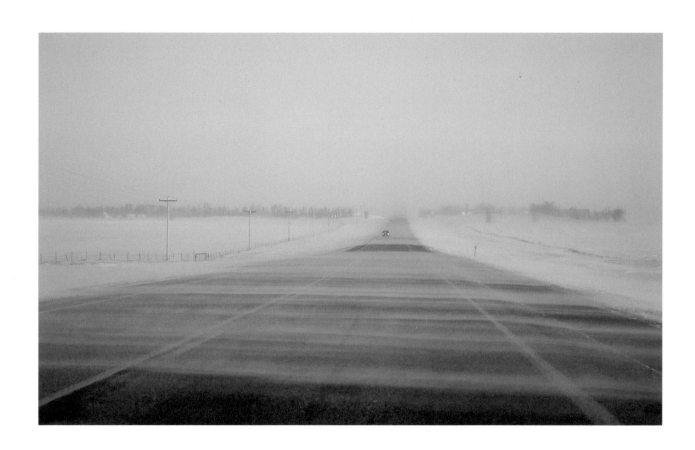

SPRING

SEASON *of* RENEWAL

ONE MARCH MORNING, after a few days of warming winds and dripping snowbanks, the ice cracked free on the Frenchman River. I didn't hear the booming sounds myself, but reliable sources described them to me. All at once the river began moving, broken chunks and great pans of flat plate ice thirty feet across and more, gliding swiftly downstream. A startling sight. All winter long, the Frenchman had been locked rigid in a visclike grip. Now this surge of release, this rush, this clunking of colliding ice as it slid southward toward Montana. I stood on a little bridge and watched the waters rise, listened to the splash and gurgle amid background trills of birdsong. The banks were already overflowing with seasonal flooding, the serpentine coils of river channel indistinct beneath turbulent brown water.

. . .

The first leaf buds emerge in April
in the Cimarron National Grassland, Kansas.

[109]

Downstream a mile or two from the bridge, two golden eagles perched motionless on the spreading branches of a huge, gnarled old cottonwood tree. Dead for some years, it loomed black against the pale spring hills. Between the eagles sat a large mass of sticks—an old nest, freshly renovated. Two eggs would soon arrive. Like the newly awakened river, all the prairie would soon be teeming with renewed life.

The resurgence begins far to the south in March and April, with two widely separated but indicative events. In Texas, the famous Hill Country wildflower bloom bursts across fields and along roadsides, drawing tourists by the thousands. Although much of the display is the result of seeding native forbs on a widespread scale—strictly speaking, not "natural"—state parks such as Lost Maples and Enchanted Rock reveal this southern prairie as it must have looked a hundred years ago. By early April, days are warm but not overbearingly hot, the claret cup cacti are opening bright orange flowers, lizards scurry over warming rock surfaces, and turkey vultures circle on thermal updrafts. This is spring on the southern prairie.

Meanwhile, in south-central Nebraska along the Platte River, tens of thousands of sandhill cranes make an annual March stopover on their way north to breed. The Platte serves as a critical way station, supply depot, and hotel for these long-legged creatures, their arrival in still-wintry conditions drawing bird-watchers and naturalists from far and wide. Here the winds are still numbing, often brutal. While Texas basks, Nebraska shivers.

In April, camping north from Texas through the prairie states, following spring—and at times getting too far ahead of it for my own

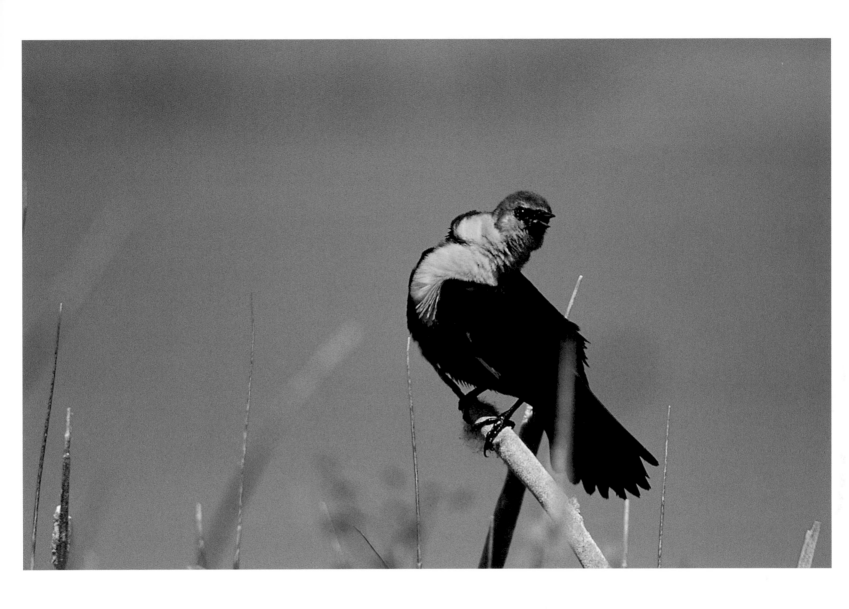

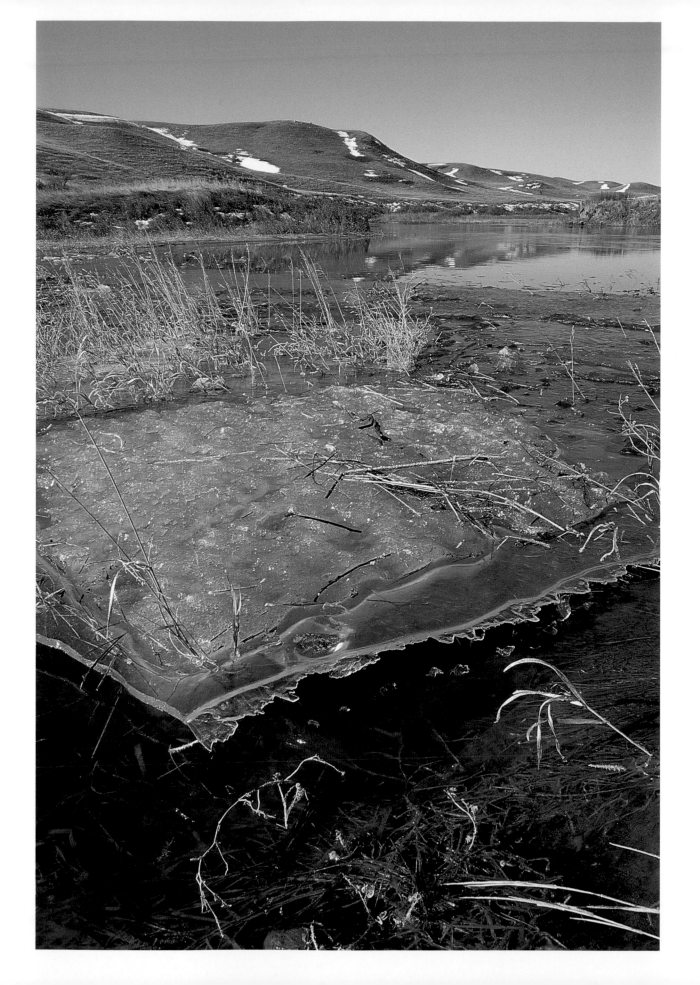

comfort—a little-known park in the Oglala National Grasslands of northwestern Nebraska quietly reeled me in. Toadstool Geologic Park had a tiny, clean, entirely vacant campground and a trail leading through spectacular badland formations. Although not as extensive as the more famous badlands of the Dakotas, these soft sandstone hills, eroded into fantastic shapes and patterns, carried a paleontological gift: a 30-million-year-old fossilized animal trackway three-quarters of a mile long. Two species of rhinoceros, using a muddy streambed as a path, speeding up from a walk to a run, heading downstream, were followed by giant wild scavenger pigs—pleasant thought! My layperson's eyes could not make out the fossilized splash marks that reveal the direction of this ancient water flow, but the tracks themselves are obvious; I would have found them even without the trailside pamphlet. Looking up from my viewfinder near a gully that has cut into the trackway, breaking and toppling huge chunks of it at random down the embankment, I half expected to hear pig grunts. But there wasn't even a whisper of wind that morning. All around me lay the bright, cold badlands, a moonscape of contorted rock. Spring was close at hand, however; I could feel it. Something invisible was moving beneath stolid surfaces, gathering energy to push new life through the dry prairie crust.

Of the myriad bird species that act out courtship rituals across the spring prairie, few are more interesting than the galliformes—game birds that include prairie-chickens, pheasants, and grouse. I watched lesser prairie-chickens from a viewing blind in the Cimarron National Grassland, Kansas, and both sage and sharp-tailed grouse from my car

in Saskatchewan. To visit a lek, or dancing ground, you must arrive early, usually before dawn, and be prepared to wait. It will be cold; there may be snow on the ground. The birds are wary, but they will usually accept the sound of a camera shutter clicking from concealment. Your priority must be to enjoy their antics without disturbing them during this critical juncture in their breeding cycle.

Sharp-tailed grouse begin gathering on leks in southern Saskatchewan as early as late February, and if summer arrives late, they might carry on well into May. The peak time here is early April. Most of the action centers on displays of male dominance and desirability. The male objective is to stake out the best and biggest territory toward the center of the lek, defend it against other males, and attract a female to it for mating. Knowing this, I positioned my car before dawn at the edge of a lek that sits beside the main road in Grasslands National Park and sat back quietly to wait for the sunrise and good light. Because activity occurs all over a lek, I tracked one individual at a time through the viewfinder, zooming in, trying to anticipate.

A male grouse extends his tiny head forward, violet neck sac inflated, wings bending downward, white-edged tail pointing up, stamping the ground while rotating in a circle. His voice a low coo, with residual cackling. Cacophony of grouse voices rising and falling across the lek. Explosion of wings as he takes a run at a rival that flees, half-flying to escape, banking in quick turns just above the sagebrush. Nearby, two males settle on the patchy snow, beak to beak, a temporary truce. Now they simultaneously stand, increasingly agitated, signals passing between

them unfathomable to a mere human, glints of sun off black eyes. My motor drive whirrs and fires, roll after roll, until the chicken talk abruptly ceases, and in a sudden flurry of wing beats the show ends. Nothing remains but an empty lek and silence. Rites of spring, grouse-style.

Soon comes the great influx. Sandpipers and waterfowl arrive in force, stopping at well-tested, hospitable locations: J. Clark Salyer National Wildlife Refuge in North Dakota, Medicine Lake National Wildlife Refuge in Montana, Chaplin Lake south of the Trans-Canada Highway in Saskatchewan. American avocets, marbled godwits, killdeer, willets, long-billed curlews, mallards, blue-winged teal, pintails, American wigeons, Canada geese. One day the prairie skies are dotted again with hawks: Swainson's, ferruginous, harriers, and kestrels. Rodents, beware! Yellow-headed and red-winged blackbirds vie for territory in the marshes, calling raucously, flashes of color against still-drab cattail stalks. Eastern and western kingbirds find nesting space on horizontal tree branches, as do nighthawks and other arboreal-minded species; meadowlarks build dome-shaped nests in grassy tussocks, while horned larks use grass-lined depressions in the prairie ground. Each species fills a niche. Lostwood National Wildlife Refuge, in North Dakota, boasts 226 resident and transient bird species; J. Clark Salyer claims 250. Prairies in spring are synonymous with bird life and birdsong.

While this great northern migration is going on, flooding in the valley bottoms reaches a peak. Across the prairie, some trees, such as the plains cottonwood, need floodplain conditions to propagate new seedlings. Consider that 85 percent of prairie wildlife uses cottonwoods for

ABOVE: *The prickly rose brightens roadsides*
and coulees across the northern prairie
in late spring. RIGHT: *An ancient cottonwood is*
dwarfed by the immensity of land and sky in
the Frenchman River Valley.

· · ·

Spring

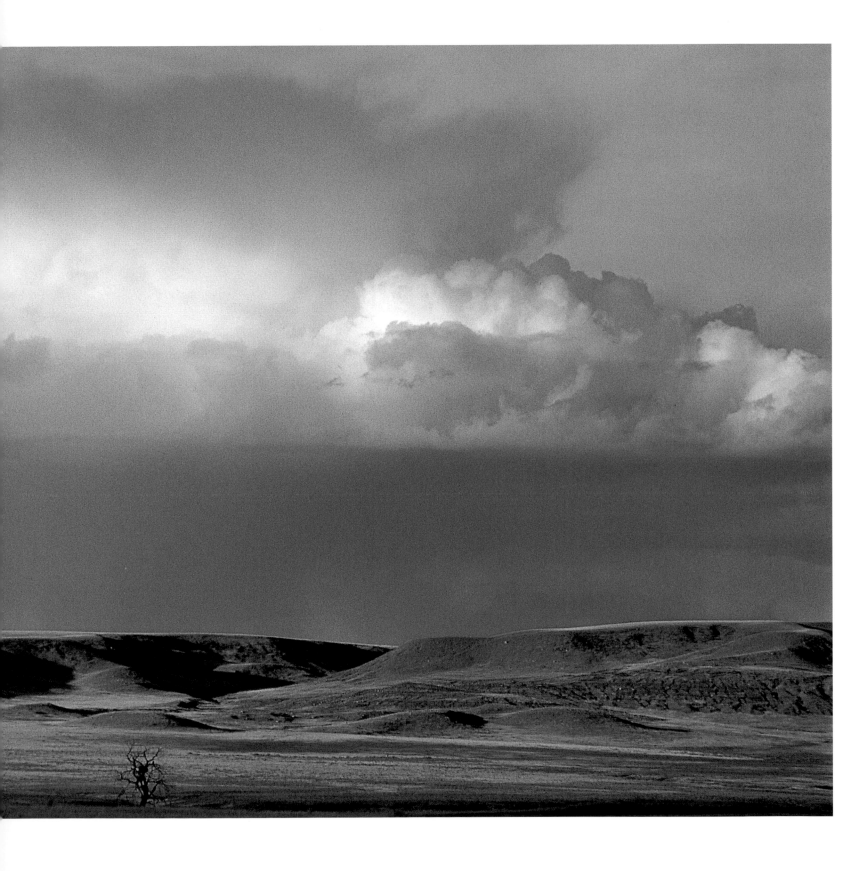

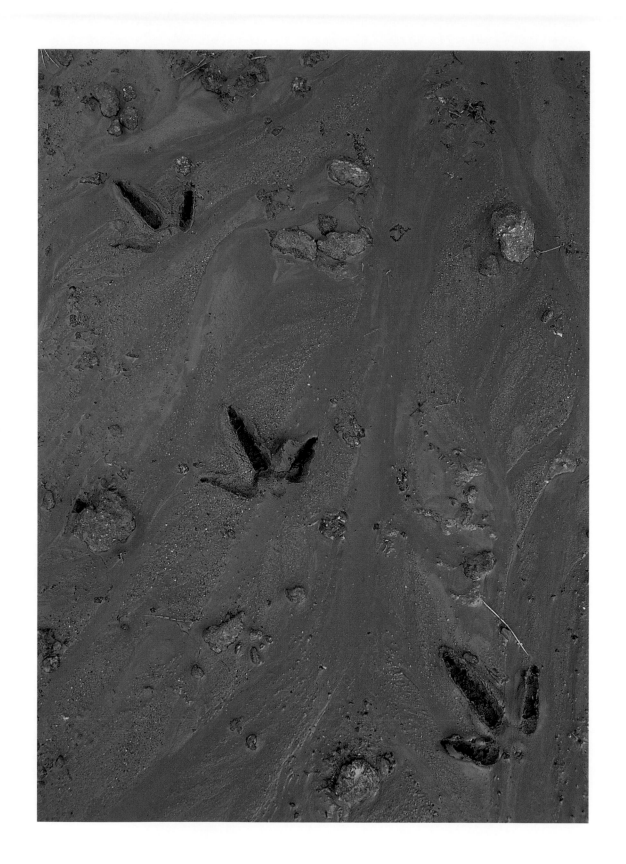

LEFT: *Wild turkey tracks in wet mud at Palo Duro Canyon State Park, Texas.* BELOW: *Thorns and shadows create patterns on a prickly pear leaf at Enchanted Rock State Natural Area, Texas.*

. . .

In the warming days of late spring,
insects such as this butterfly resume their
activity on the northern prairie.

. . .

breeding, shelter, or food; clearly, these widely spaced river ecosystems within the prairie must be kept vital and productive. Studies indicate that the historical pattern of seasonal spring flooding serves this purpose best. The wispy, seemingly insubstantial airborne seeds of cottonwood must be kept moist to germinate and must arrive in a soft loamy or silty environment to set roots.

Unfortunately, most prairie rivers have been dammed or otherwise controlled to prevent flooding. As a result, in prime riparian habitat such as Alberta's Dinosaur Provincial Park, where the Red Deer River has cut deeply into badlands and created a valley bottom of floodplain and cottonwood groves, relatively few younger trees are evident among the twisted old ones. Today some park managers use controlled flooding to replicate the natural cycle and ensure continuance of healthy riparian ecosystems within the great prairie matrix.

TAKE A WALK through a prairie cottonwood grove in May. The mature trees cluster and squat, their deeply furrowed bark suggesting solidity and endurance. On the ground beneath their gray-green crowns lies a wild tangle of woody shrubs, prairie grasses, and forbs, from prickly rose to golden bean. Dry branches snap beneath your feet. A great horned owl silently observes your progress, gliding away when you make accidental eye contact. You don't notice its mate, high up in a nearby tree. Now a hollow drumming on bare ground as a mule deer doe springs away, all four hooves in the air at once—*boing! boing!* Another mule deer, heavy with unborn twin fawns, watches until you

Spring

A stunning double rainbow
appears during a powerful rain- and
windstorm in Saskatchewan.

. . .

are very close and then, with tentative, quiet steps, turns away to disappear into a thicket. Later, you will see two whitetails, always more timid, leaping effortlessly over fallen tree trunks as they flee the area you have invaded. Silence now; you sit in the cool shade of an old cottonwood and lean back against rough bark. Five minutes pass; then ten. Suddenly, from nowhere, a northern flicker rockets through the air between tree trunks and alights nearby on a standing dead snag to rap on deadwood with needle-sharp bill. Five or six American goldfinches, already occupying the highest, outer branches of the same tree—how did you miss them?—shift nervously but hold their position. And so it continues, the cottonwoods offering food and shelter, the prairie species accepting. It is obvious now—these trees give life.

Out on the exposed prairie, spring takes longer to establish itself, especially in the mixed-grass and short-grass regions of the northern plains. The snow can melt in a few days of sunshine and sun-warmed wind, turning frozen soil into quagmire and shortly thereafter into baked, cracked prairie earth. And then—nothing. Or rather, nothing readily apparent. The transformation seems stalled.

Then, one day in April, purple clusters of prairie crocus (*Anemone patens*) spring up between bunches of desiccated grasses, their fuzzy stems capable of trapping warm air and thereby protecting the plant from nighttime lows. Prairie crocus is the first showy flower to bloom in the north, harbinger of spring. Warming weather will spell the end of its flowering season, but for several more weeks the plants will remain conspicuous as tall, bare stems topped with filamentous seed heads.

*The fastest mammals in
North America, pronghorn can sustain
speeds above 50 miles an hour.*

. . .

Now, leafy musineon, golden bean, wild mustard, and moss phlox—
mostly yellow and white flowers—take their turn in the sun, followed
eventually by scarlet mallow, scarlet gaura, the milk-vetches, prairie-clo-
vers, cacti, and many more. Farther east, the tall-grass remnants offer
an even greater flowering abundance. Meanwhile, grasses also appear in
the lengthening days. Across the prairie tapestry sand reed grass, June
grass, foxtail barley, northern wheat grass, spear grass, blue grama, big
and little bluestem, and dozens of other species poke through prairie
soils, seeking the sun.

Spring on the northern prairie is a tenuous proposition; fresh green
grass shoots are no guarantee of anything. Just when you think win-
ter has been vanquished, a surprise storm comes howling down from
mountain slopes, complete with plummeting mercury and sometimes
a big, unwelcome dump of snow. So it went one year in late May. I
had driven to Alberta, hoping for some idyllic photos of sparkling fresh-
ets in the foothills and maybe some returning waterfowl. Instead I was
greeted by knee-deep snow that blocked all the back roads, closed
campgrounds, paralyzed daily life in the small prairie communities in
the storm's path, and confined me to motel rooms until I finally found
the wisdom to go elsewhere. A week later, temperatures jumped from
below freezing at night to daytime highs above 80°F. A jarring contrast.
That same year I came back to the Alberta foothills in mid-September
and was snowed out of my campsite. Less than 120 days between last
and first snowfall. No wonder the time in between is filled with such a
frenzy of activity.

Spring

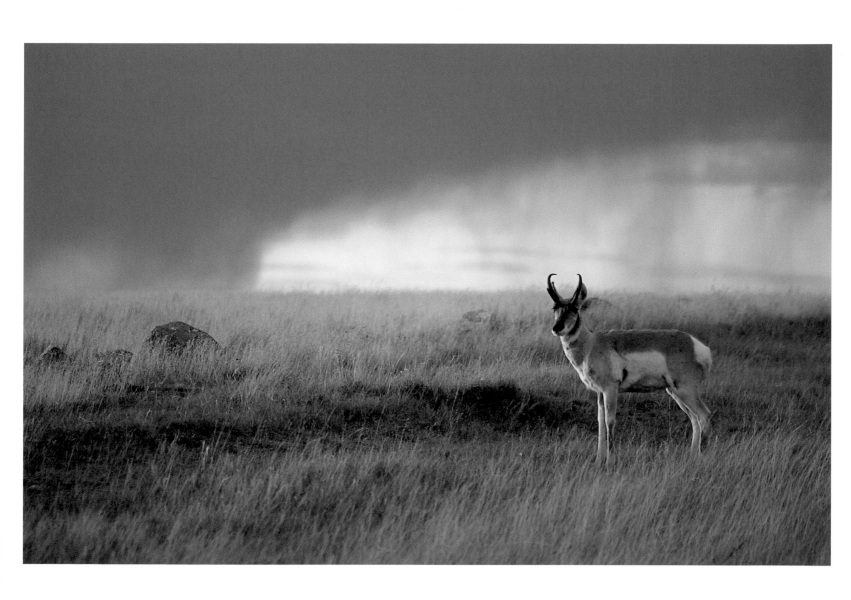

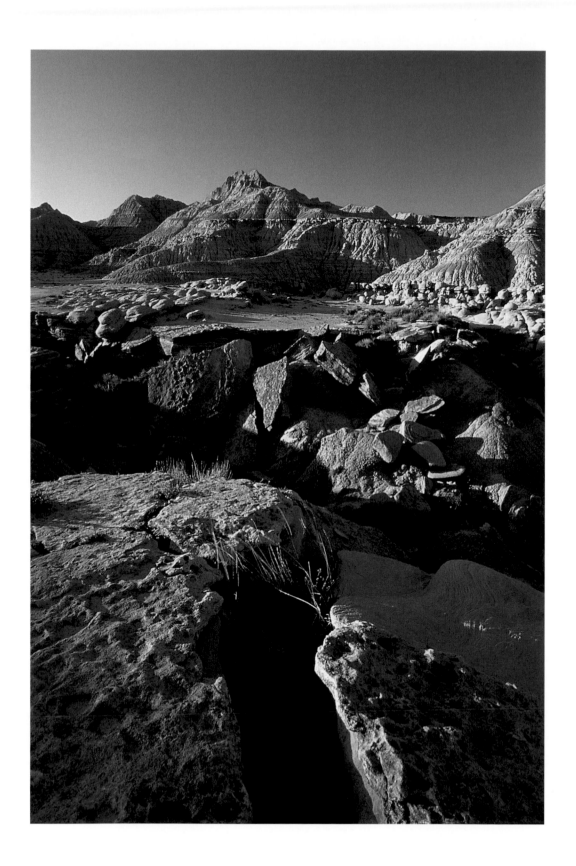

On an animal trackway in Toadstool
Geologic Park, Nebraska, the fossil record of prehistoric
rhinos and giant scavenger pigs lies
exposed in a bizarre badlands landscape.

. . .

On the prairie the weather is a wild card—the ultimate joker, unpredictable and unreliable. But there is a flip side to the rude surprises. When cumulus clouds stack themselves high, pile after pile above the endless horizon, drenched in warm, resplendent sunshine, there is no place more breathtaking. The wind that can rattle your bones until you think your flesh will rip off in shreds also makes the grasses wave and drives cloud shadows like ghost herds of buffalo across bright prairie ground. The pyrotechnics of prairie storms are free for all to enjoy, provided you survive them. And the grim times of blowing dust, the danger times of giant hail or rampaging tornadoes, the monotonous times when it seems the world has gone featureless and lifeless and will never change—those times that call for endurance and patience—are balanced by gentle interludes of impossible sweetness and light.

If the transition from prairie winter to prairie spring can be abrupt—albeit with confusing setbacks and periods of meteorological chaos—the spring-summer delineation is not so clear. Exactly when does spring end and summer begin? Calendar dates notwithstanding, there is no definitive moment but rather a gradual relaxation, a slow sliding into a world of green. The leafing out of aspen and willow isn't sufficient; there are too few trees to have much impact. Pockets of newly green trees line the widely separated watercourses, the boggy bottoms and wet seeps, the coulees that have retained a little moisture from snowmelt or the occasional underground spring. But overall, the prairie remains brown until the grasses and forbs return to fullness. And then entire hillsides are transformed with chlorophyll. The greening prairie rushes to meet

Morning dew clings to western wild
bergamot and big bluestem in tall-grass prairie
near Crookston, Minnesota.

. . .

summer solstice, and at some nebulous point the transformation is complete. Perhaps the surest signal that summer has finally asserted itself is the year's first lightning storm—whenever it may come.

It was on this cusp, in the newly green prairie of late spring or perhaps early summer, that I visited North Dakota with a shoot list that included flower species, badlands geology, birds, insects, and large hooved mammals. The last item would be fairly straightforward; Theodore Roosevelt National Park is home to a substantial herd of free-roaming bison. They are easy to find and easily photographed. But this prairie icon can be a dangerous beast. Equipped with my longest telephoto lens, I took a walk on the wild side of a big bull bison in early June in the park. It is possible to share common turf with most animals, provided you respect their fight-or-flight distance, which is different for each species and for different individuals within a species. Careful observation is required. There is little margin for error. I kept back 300 feet or more, allowing the solitary bull to become aware of me in increments.

Things were proceeding well until I followed him along a trail that dipped sharply down a gully and into tree cover. Suddenly I realized that I had lost sight of him and that my visibility was severely limited. I could see his fresh tracks in the dust, but there was no guarantee that he might not have doubled back on me through the trees. I hesitated, imagining a gigantic form looming out of shadows, and turned around. Back up the trail, at a hilltop view over gully and prairie, there he was. He had doubled back, but on the opposite side of the gully, and now

Spring

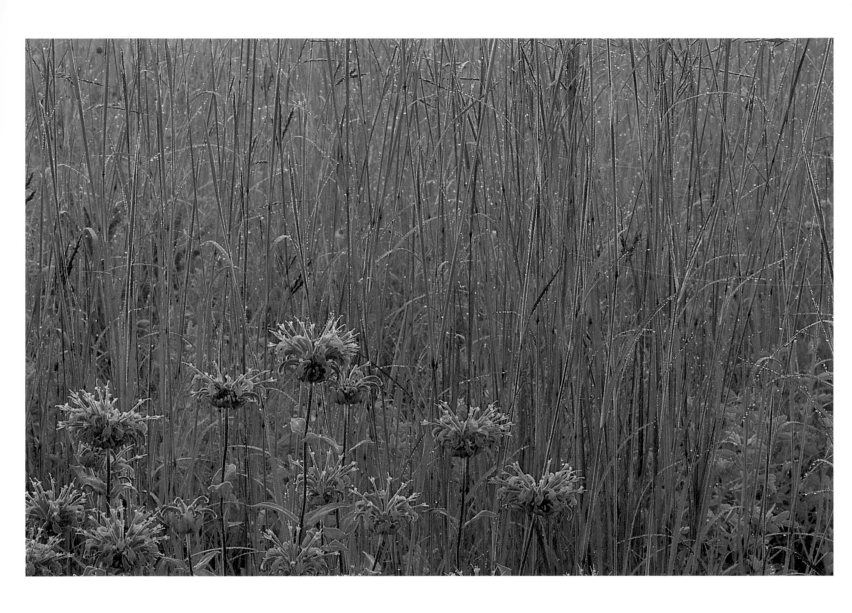

The bright bloom of a compass
plant beams over Konza Prairie in
the Flint Hills of Kansas.

. . .

Spring

shuffled along a grassy ridge, grazing in afternoon sunshine, composure unruffled, physically closer to me than before but with the comforting barrier of trees and steep incline between us. I made my photographs, grateful for the outcome. It felt like good medicine to me, a close encounter to remind me to keep my head up. The buffalo commands respect, which is a little different from deserving respect. All creatures deserve respect, but they aren't all capable of trampling you into pulp. It seemed to me that those bored tourists who tear along the park roads, driving too fast, seeing nature as scenery, would do well to walk with a wild bull bison across a stretch of open prairie.

In North Dakota's badlands, I watched the final touches of spring spread across the prairie. One night it rained heavily; the ground soaked it up. The green mantle glowed for days afterward. Traveling north again, up through the rolling hills and prairie potholes that breed the continent's ducks, I met nothing so imposing as a bull bison. Back home I could feel summer again, unmistakable in the furious hot buzzing of green sweat bees inside yellow prickly pear blooms, in the approaching rumble of a thunderstorm. The prairie always seems to have something to say, either whispering with a soft sweetgrass breath or roaring expletives in your face.

IN THE END, after a full rotation through the seasons, and another, and yet another, I had a sense of the prairie, or at least a few clues. It has been hammered by forces ranging from geophysical to social and political. Yet even today, after massive encroachment, upheaval, and

Spring makes a languorous transition into
summer in the oak savanna prairie at Agassiz Dunes
Scientific and Natural Area, Minnesota.

. . .

change, it survives—mostly altered, but still vital, especially in natural preserves and parks—to challenge and enthrall anyone open to its offerings. Through seasons of fire and ice, it can spark the imagination; it can speak to you of things long past or make your heart race for the pure joy of being alive, here, now, in this most vital of living landscapes. Prairie is mythological in scope, mysterious in its impact on the psyche. It is a place to dream great dreams. But it is also real and awaits our future foolishness or wisdom. We have learned how to survive the prairie seasons and absorb its lessons. But can the prairie survive us? A few more rotations and we may have the answer.

Spring

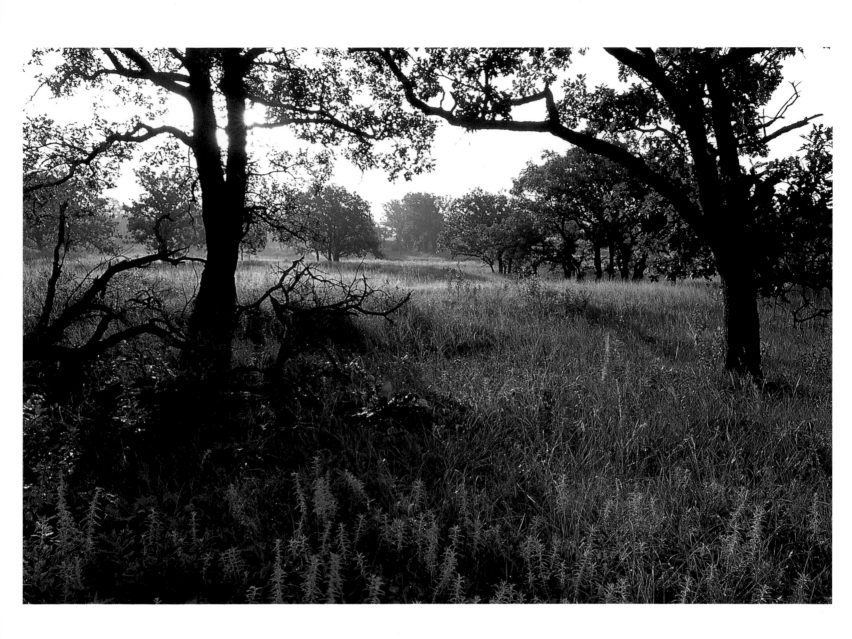

ACKNOWLEDGMENTS

WITHOUT THE ASSISTANCE of many individuals, this book would not exist. My heartfelt gratitude goes first to Robert and Mette Ducan and their grown offspring, Kristine and Adam, who welcomed me into the wonderful, chaotic milieu of their family, at times feeding and housing me, all the while providing me with the opportunity for an ever-deepening relationship with the Saskatchewan prairie they call home.

Thanks also to Colin Schmidt of Grasslands National Park for his help and availability, to Parks Canada warden Brian Spreadbury for sharing his knowledge of the park and its wild inhabitants, to biologist Pat Fargey and the inimitable Karin Smith-Fargey for useful information and good cheer, and to all the Parks Canada staff who generously shared their insights with an itinerant photographer. The U.S. National Parks staff, as well as state and provincial parks personnel on both sides of the border, were generally friendly and helpful. Likewise, I appreciated the many independent experts in different fields who suggested shooting locations and identified birds and wildflowers for me, often via e-mail.

The patience and guidance from publisher Rob Sanders, editor Nancy Flight, and designer Peter Cocking at Greystone Books throughout the inception and completion of this work made it happen, plain and simple. Joan Henley told me to dream bigger, and I've not forgotten this advice. Curt Yoder made prints for me that landed on a gallery wall; these were seen by Candace Savage, who recruited me to shoot the photographs for her splendid *Prairie: A Natural History,* a project

that led directly to this one. Thanks to Bob Harwood and Pam Woodland, who offered useful critiques of the manuscript in its early stages, and to Arlene Rees, whose insights and daily feedback on both the writing and photography have helped shape this project significantly as it moved toward completion.

Finally, enduring gratitude to my mother, Irene, and my father, the late James S. Page, for their early support and encouragement. If one aspect of parenting is to endow the young with solid values, an equally important one is to allow their hearts and minds to develop according to who they are, not who we want them to be. Some gifts just can't be quantified. It's a long way from boyhood and my first box camera, but the early lessons imprinted well and accorded me the psychological freedom to go ahead and break my own trail as an adult.

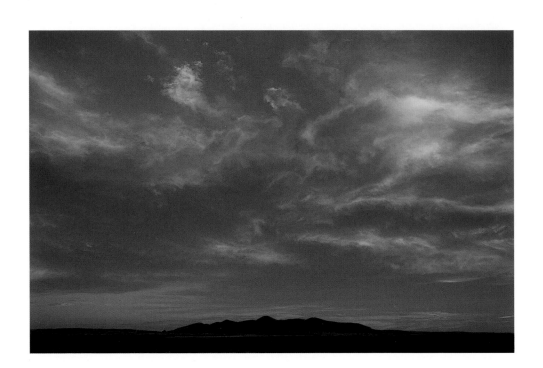